GESAR!

GESAR!

THE WONDROUS ADVENTURES
OF KING GESAR

Dharma Publishing

 TIBETAN ART AND CULTURE SERIES

1. Sacred Art of Tibet
2. Psycho-cosmic Symbolism of the Buddhist Stupa
3. Tibet in Pictures
4. Art of Enlightenment
5. Gesar! The Wondrous Adventures of King Gesar

LIBRARY OF CONGRESS CATALOGING IN PUBLICATION DATA

Gesar (Mongolian version). English. Selections

 Gesar : The wondrous adventures of King Gesar
 p. cm.

Summary: Describes the birth and epic adventures of the legend-
ary Gesar, mighty king and protector of Tibet.
 1. Gesar (Legendary character) 2. Mythology, Tibetan.
I. Title

BL1950.T5G47 1991 398.22'0951'5–dc20 91-35260
ISBN: 0–89800–223–0 pbk.: acid-free

Adapted by Zara Wallace
Illustrations by Julia Witwer

Editing, illustration, and design by Dharma Publishing
Typeset in Mergenthaler Palatino
Printed and bound in the USA by Dharma Press

00 9 8 7 6 5 4 3 2

CONTENTS

*Dedicated to all who delight
in the freedom of the human mind*

INTRODUCTION

*O*ne of the world's great epics, King Gesar's adventures have been celebrated in legend and song throughout Tibet and Central Asia for nearly a thousand years. Hundreds of versions of the Gesar epic exist, both in written forms and in an oral tradition that is centuries old.

Tales of Gesar's miraculous adventures told by wandering bards attracted crowds everywhere in Tibet. His heroic deeds took Gesar to lands and realms far removed from his kingdom—to India, China, and Turkestan, to the land of the twelve-headed giant, and even to the realm of the lord of death. Appearing in many guises, as master magician, divine trickster, wise king, fierce warrior, or spiritual teacher, he subdued the most cunning and powerful oppressors, and brought prosperity and blessings to his people.

This selection of tales follows Gesar from the realm of Kormuzda, lord of the gods, to his birth in the human realm, his growth to manhood, and his es-

tablishment of a kingdom. We witness the manifestation of his powers as he wins Brugmo as wife and draws his thirty hero-companions to him. Though our modern sensibilities may protest as we enter this warrior's world of early Tibet, the heroic sweep of events suggests that all is not what it seems.

Gesar and his heroes manifest a generous, open-hearted attitude of fearless engagement of all aspects of life. In this dynamic warrior-world of the psyche, there is no place for meanspiritedness, for forgetfulness, for the soft yearnings of ownership and desire. Whether they surface in male or female form, in Trotun, in Aralgo, or even in Gesar when he drinks the elixir of forgetfulness, such qualities do harm to self and others, and must be transformed. Those who can not, or will not transcend these qualities cannot thrive in the warrior's realm.

Gesar's heroic task is to overcome the dark forces, both inner and outer, that bring war and hardship and obscure the path to enlightenment. Each character in the epic, from Lord Trotun to the three celestial sisters that guide Gesar in his quest, symbolizes a psychological and spiritual force. Gesar harnesses and unifies these forces, just as he unifies his kingdom. Gesar's ultimate victory promises that peace, harmony, and enlightenment will prevail in the world.

Interpreted symbolically, King Gesar, representing freedom and liberation from the bondage of igno-

rance, is the King of the human mind, in all its aspects. His kingdom is the realm of restless experience that must be unified and strengthened. The treasure to win and protect is our own understanding. The enemies that we must conquer are emotionality and ignorance. Once these are overcome, the path of liberation is in sight, and our lives and our struggle for survival take on the character of a quest for ever-widening and enriching experience.

Gesar is called the Great King because his strength is based on awareness. Ultimately, he meets every challenge successfully because his energy is open and flowing. This kind of energy encounters a situation directly and deals with it spontaneously, in the best possible way, thus supporting an infinite growth process open at every point.

Brugmo's pride, like the pride of Sanglun and Shikar, Gesar's human father and brother, must be brought low before her true strengths can surface. The 'evil' Trotun's chief folly is that, no matter how foolish his actions, he never allows his pride to be broken. His energy and resourcefulness turn toward chaos and discord, inflicting suffering on everyone around him. And, while our hearts go out to Aralgo in her distress, and she wins our admiration with her resourcefulness and courage, all these virtues are lost when she allows self-centered desires to triumph and seeks to bind Gesar to her and her alone.

Mingling historical record with mythical tale, the Gesar stories remind us that every experience is a subtle blend of past memory and future projection, shifting into actuality in each moment of time. Once this is understood, the past can be directly tapped, not as a static "event" but as a reservoir of clarity flowing into our lives.

As King, Teacher, and Hero, Gesar is freed from the limitation of time and space. In his spiritual aspect he symbolizes courage and freedom, and inspires a process of transformation. The creative vision he embodies can help us see through superficial aspects of life and strengthen clarity, confidence, and the resolve to engage experience directly.

The creative vision embodied by Gesar inspired the creation of Gesar Magazine, which has presented new translations from the Gesar epic in each issue since its founding in 1973. In recent years, Dharma Publishing has developed The King Gesar Series to introduce children in the West to these stories so widely enjoyed in Tibet. This presentation of the Gesar epic for adults has been adapted from a Mongolian version initially compiled by I. J. Schmidt in 1836 under the auspices of the Imperial Academy of Sciences in St. Petersburg. Published in German translation in 1839, it was translated into English by Ida Zeitlin and published under the title *Gessar Khan* (New York: George H. Doran Company, 1927). This new version rephrases the Gesar story in the modern English idiom.

CHAPTER ONE

THE HERO'S BIRTH

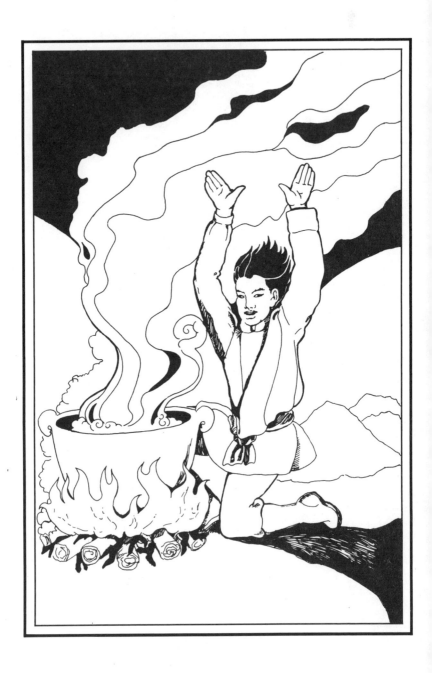

THE HERO'S BIRTH

ormuzda, father of the gods, ruler over the high heavens and guardian of the earth, came down from the great mountain Sumeru and knelt at the feet of the Buddha, fountain of good and light of all the world. He bowed his head nine times before the Buddha, paying homage and requesting the Buddha's blessing.

"Your homage, noblest of gods, is as sweet as the breath of incense," said the Buddha. "Hear now my word. Return to Mount Sumeru, and for five hundred years let there be joy and feasting in your kingdom. Know that after five hundred years have passed, an evil time will afflict all beings on earth. Brother will make war against brother, wild animals will devour their mates, pastures and rivers will be stained with blood, and peace will perish like a rootless tree. When that day comes, give up your merrymaking and have one of your three sons descend to earth, disguised as a human being. Let him rule the earth, destroying the

tenfold evil and restoring gladness to the hearts of the people."

Kormuzda bowed his head to the Buddha and returned to Mount Sumeru. For five hundred years he feasted among the thirty-three gods over whom he ruled. But when five hundred years had passed, he forgot the Buddha's command. He feasted for another hundred years and then another.

Suddenly a roar shattered the heavens, as though ten thousand dragons called to one another simultaneously. Amazed, Kormuzda saw the great wall that guarded his kingdom on the west shudder and fall, crumbling into ruin.

Angered, Kormuzda took up his sword, crying out, "Who dares to attack the walls of the high gods? I challenge him to combat, even if he is the dragon with fifteen heads or the lord of the Asuras! The victor will rule over my kingdom in triumph."

But no one responded to his challenge. He went up to the shattered wall, but no fifteen-headed dragon appeared. Nor did he see the ancient enemies of the gods, the Asuras who live at the foot of Sumeru.

Suddenly he cried out in anguish, "It is your hand, Buddha, All-Seeing One, that has chastened me! For you commanded me, after five hundred years, to send one of my sons to earth, to destroy the evil and restore gladness to the hearts of men. And now seven hun-

dred years have passed and still we live in pleasure and ease on Mt. Sumeru!"

Kormuzda sent a messenger to find his sons. The messenger came first to Ameen, the oldest.

"Ameen, beloved son of your father! Kormuzda bids you to descend to earth to rule human beings with wisdom."

"I am unschooled in wisdom," Ameen replied, "unfit to rule human beings. How my father's name would be shamed if I tried this task and failed! No, for the love I bear my father, I cannot do his bidding!"

The messenger went to Weele, Kormuzda's second son, and said, "Beloved of your father, Kormuzda bids you descend to earth to rule human beings with wisdom."

Weele answered, "I am the son of a mighty god, and those creatures that crawl upon the surface of the earth are human beings. What are they to me? Let Ameen do my father's bidding—it is proper for the oldest son to be first in deeds of valor. Or, if he wishes, let Tagus descend to earth. I yield my right to him. But as for me, I have no liking for this enterprise, and I will not go!"

So the messenger went to Tagus, Kormuzda's youngest son, and said, "Beloved of your father! Kormuzda bids you descend to earth to rule in wisdom over the beings there."

"Why do you come to me with Kormuzda's word?" asked Tagus. "Shall I usurp my brothers' duty? My heart is ready and my feet impatient to do my father's bidding, but I am afraid to bring dishonor on the heads of those I love."

The messenger returned to Kormuzda and told him what his sons had said. And Kormuzda, seated on his throne, commanded his sons to appear before him.

"When I commanded you, beloved sons," he said, "to live upon the earth, to cleanse it of corruption and to rule human beings with wisdom, this was not done to please my fancy, but in obedience to the will of the Buddha, the Shining One. I thought you were my children, but now it appears you are the father, and I the dutiful son. Therefore take my place on Sumeru—wear my royal robes and my crown, assume my majesty and might, and lay your commands upon me!"

His three sons bowed their heads before their father's wrath. "Why does the king of heaven speak so bitterly?" they asked.

Ameen, the eldest, said, "Well do I know that this task is greater than my strength, and therefore I refused you, father. For men would say: 'This braggart says he is Kormuzda's son, and comes to rule us. But his sword is powerless and his puny arm falters before our enemies. Kormuzda's son indeed! What kind of a god is this that breeds such a weakling?'"

Then Weele spoke, saying, "When the seventeen gods of Ishwara's realm meet on the field to vie with one another in feats of skill and valor, whose arrow speeds more swiftly to the mark than Tagus' arrow? When the dragon-princes of the deep contend for the crown, which of them can measure his strength against the strength of Tagus? When the thirty-three who surround your throne make a trial of arms, what blade can prevail against the wonder-working sword of Tagus? Then let Tagus descend to do the Buddha's will, for he alone of your sons is worthy to bear your name in the human realm!"

"That is the truth!" said those who stood around Kormuzda's throne.

Kormuzda turned to look at his youngest son and said, "Will you undertake this task, my valiant son?"

"Yes," replied Tagus. "I will undertake it."

"What treasures will you choose from our royal store to lighten your labors on earth?"

"Your armor made of seven jewels that sparkle like the dew at dawn, your helmet made of the woven light of the sun and moon, your lightning-sword three fathoms long, and your ebony bow, with thirty silver arrows notched in turquoise."

"They are yours!" answered the king.

"Let three dakinis be born of the mother who will bear me, and let them mount again to Mt. Sumeru and look down upon me, to turn my footsteps away from danger," said Tagus.

"This shall be done," said the king. "Amirtasheela, daughter of Bayan, shall give you birth."

"Let one of the best-loved of all your kinsmen live at my side as my true friend."

"This shall be done, and Sanglun, prince of Tussa, will be his father," said the king.

"Let thirty of the lesser gods follow me to earth to be my steadfast comrades. From the royal herds give me the bronze-colored steed that runs faster than the fox, more swiftly than the antelope or even the river after spring rain. These are the treasures I choose from your royal store to lighten my labors on earth!"

"These treasures are yours," said the king. "Go now, Tagus, to prepare yourself for human birth. On earth you will be known as Joru until you are fifteen years old, and then all will know you as Gesar, the son of heaven, hero of the ten great regions of the earth, conqueror of all evil and emissary of Buddha to mankind!"

Tagus said farewell to the assembled gods, bowed before his father, and went to prepare himself for human birth.

Now in Tibet there lived two mighty princes, Sanglun the Good, who ruled over Tussa's tribe and his brother Trotun of the false heart, who ruled over the tribe of Lik.

One day Trotun came before his brother and said, "Let us make war on Bayan our neighbor and seize his lands, for he plots evil against us. When we have overthrown him, I will divide his people and his herds with you. But his daughter, Amirtasheela the Fair, shall be my prize."

So they rode against Bayan. Sanglun rode ahead and Trotun rode behind him. But when the camp was destroyed, the warriors slain, and the people were fleeing in fear, Trotun galloped to the head of the forces with a loud cry. Amirtasheela fled before him, but, stumbling in her flight, she injured herself, and so was taken captive.

Then Trotun, with black heart, betrayed his brother and took for himself all the flocks and lands and all other spoils of battle. To Sanglun he said, "I will give you Amirtasheela, brother, to give you comfort. She is lame from her injury and drags herself about like an old woman. I will have none of her!"

Sanglun took pity on Amirtasheela and gave her shelter in his home. When her injury healed, she walked as lightly as a soft-footed doe, fairest of all the daughters of Tibet.

Now Trotun became envious; he wanted to take her into his household, but she refused him. With his heart filled with hatred, he went secretly among the people, whispering, "The evil that has fallen on mankind springs from the union of Sanglun with Amirtasheela."

"Let them perish for the evil that has come upon us!" the people cried.

Trotun summoned Sanglun and Amirtasheela before him, and his voice flowed like honey from the comb. "The tribesmen clamor for your death, Sanglun, and for yours, Amirtasheela. Yet I, being merciful, will spare your lives and sentence you instead to exile where the three rivers meet. There you may gather firewood to warm you, and out of my goodness I will bestow upon you a piebald camel and her colt, a dappled mare and her foal, a mottled cow and her heifer, a spotted ewe and her lamb. Your wealth shall be mine, Sanglun, and Rongsa and Shikar, your sons, will serve me as my vassals."

Sanglun went with Amirtasheela to the place where three rivers meet. Amirtasheela gathered firewood to warm them, and Sanglun led their beasts to pasture, and hunted mountain hares so that they might eat.

On an evening when the moon was new, as Amirtasheela made her way home from the forest, a voice spoke in her ear, "God-appointed one! At the

full moon you shall bear three daughters, and a son destined for lofty deeds!" The voice said no more, and Amirtasheela went on her way.

When the moon was full, she said to Sanglun, "Do not go abroad tomorrow, I pray you, Sanglun, for my heart is filled with strange forebodings, and I would have you near me to cheer my solitude."

But he answered, "If I sit idle by your side, how shall our food be snared and our few sorry beasts be pastured? Take heart, fair Amirtasheela, for no harm will come to you."

The day dawned, flourished, and passed; at nightfall Amirtasheela the Fair bore three daughters whose beauty shone as bright as clear crystal or the burning of a radiant flame. Then the sound of crashing cymbals and the beat of drums heralded the appearance of three elephants, saddled in gold and bridled in the blue that lights the heavens, descending on clouds of incense. They knelt before Amirtasheela's newborn daughters who mounted on their backs, then soared upward, carrying the girls to Mt. Sumeru.

Amirtasheela wept bitterly. "Woe, woe is me! O shining gods, why have you taken my daughters from me, before I had even held them in my arms or kissed their brows?"

As she mourned, a voice within her cried, "Let me come forth, good mother!"

11

From beneath her arm a son was born. His right eye looked askew, but his left eye gazed truly before him. He brandished his right hand fiercely above his head, but his left hand was balled into a fist. His right foot was turned up, and his left foot down, and forty-five teeth gleamed in his mouth.

Amirtasheela lifted up her voice and cried out, "What monster is this that issues from my body, and looks at me askew?"

Standing before her, he answered in a tiger's voice, "My eye that looks askew uncovers all the mischief wrought by demons. My forward-gazing eye pierces the mystery of what has been and what is yet to be. My right hand, raised aloft, bids my foes beware, while my left hand, clenched in a fist, bears witness that no enemy of the gods shall escape my wrath. One foot points downward as a sign that unrighteousness shall be crushed beneath its heel, and the other foot points up to proclaim to all mankind that Buddha's law shall be exalted to the skies. As for my forty-five sharp teeth, these are a sign that in the end I shall swallow up all evil."

"Alas," said Amirtasheela, "in Tibet a seemly baby is born with ears that hear not and a silent tongue. Yet you quarrel with me, child of sorrow, before you have lived even an hour on earth."

Now Sanglun, driving his meager herd before him and bearing on his back the mountain hares he had

taken in his net, approached the yurt and heard from within first a woman's voice, and second, the voice of a tiger. Entering the yurt, he said, "What clamor is this that rings to the shores of the sea?"

Amirtasheela answered, "Did I not bid you stay by me, Sanglun, to shelter me from harm? See now what has befallen. I bore three daughters, children of the gods, yet hardly were they issued from my body when three elephants descended out of the skies with incense and the beating of many drums and took them from my arms. Immediately afterward, this demon's spawn appeared, brawling and glowering and brandishing his arms, acting as though he would devour me with his forty-five teeth."

"How can you know that a demon sired him and not a god?" asked Sanglun. "Look on this treasure I have taken—eighty mountain hares, all in the single hour since his birth, though never before have I brought you more than seven. It may be that I laid the snares more cunningly than I usually do, or it may be that the child is blessed by heaven. Let us feed and shelter him and call him Joru."

So they named him Joru. The child Joru throve and kept Sanglun's herds—the piebald camel and her colt, the dappled mare and her foal, the mottled cow and her heifer, the speckled ewe and her lamb. As they grazed one day, he plucked three golden reeds out of the earth, and three tall nettles, and three blades of grass, and three stalks of karagana weed.

With the karagana weed he struck the camel and said, "Be fruitful, camel, and bear young as plentifully as the steppes bear weeds!"

He struck the mare with the blades of grass and said, "Bring forth a horde of foals that shall outnumber the grasses of the plains!"

The cow he struck with the tall nettles and said, "Let your seed be as many as the thorns on the nettle-stalk!"

With the golden reeds he struck the ewe, saying, "A golden lamb be yours for every reed that ripens in the sun!"

The herds and flocks did his bidding. Amirtasheela rejoiced in the power of her son, and Sanglun rejoiced in the richness of his flocks.

"I have heard it told that a thousand shall be born of one, but never till now have I seen it," said Sanglun. "Yet who will tend these flocks, Joru, that have grown too numerous for you to keep?"

"Look, Sanglun!" cried Joru. Sanglun saw that two riders galloped swiftly over the plain, and when they drew near, he saw that they were his sons, Shikar and Rongsa. They knelt at his feet. "We have escaped from the bondage of Trotun and have come to find you," they said.

14

Now the three youths tended the herds and drove them forth to pasture and lived in friendship together. Then one day his brothers saw Joru fall upon nine sheep and slaughter them. Drawing the skin from their bodies, he cast the flesh into an earthen vessel. But the bones he gathered together, laying each sheep's bones within his skin.

He built a fire under the vessel; scattering incense, he said, "Kormuzda, noble god and well-loved father, and those who stand around his throne! Dragon princes of the deep! Deities of the realm of great Ishwara! Listen to me, for I am Tagus, born among men according to the word of the Lord Buddha and at your bidding. In this poor body my spirit is housed! With this sacrifice I proclaim myself your servant and your son!"

The gods said to one another, "It is Tagus who calls upon us. Let him not call in vain." They put off the shining shapes of gods, and, in the guise of human beings, left the heavenly realms to partake of Joru's sacrifice. Joru welcomed them and led them to the feast. Shikar watched them silently, but Rongsa fled like a gazelle pursued by hounds.

Bursting in upon his father, Rongsa cried, "Joru has slain nine sheep and cast the flesh into an earthen vessel. He makes strange and foolish sounds into the air, like yea and yea and gods from above and buddhas from below and dragons of the deep and boo and boo,

and more of this that I cannot recall. Presently in answer to his cries came a throng of horsemen, whom he welcomed with loud acclaim and led to the feast, and now I have no doubt they have eaten the last morsel of your good rams."

Sanglun's wrath knew no bounds, and seizing his lash, he said, "Joru shall answer to me for this offense."

When his guests had eaten their fill and returned to the skies, Joru swung the skin of each slaughtered ram three times around his head and lo! they stood quietly among the herd and cropped the pasture. Joru drove them homeward, and his brother Shikar walked by his side.

Sanglun came to meet them, but when he would have fallen upon them Joru wrested the lash from his grasp and flung it with such force into the earth that it lay buried fifty fathoms deep.

Hearing the sounds of strife, Amirtasheela hastened to the spot where Sanglun frowned in wrath upon her son. "What is amiss, Sanglun?" she asked. "How has your son offended you that you gaze so darkly upon him?"

Sanglun answered, "This is no human child that you have borne, but some monster misbegotten of a fiend. Rongsa has told how he slaughtered nine sheep to make a feast for beggars. When I would have pun-

ished his insolence, he flouted me and cast my lash fifty fathoms into the earth."

"Fie on you, husband, for a graceless churl!" cried Amirtasheela. "Was it through your skill that the few wretched beasts bestowed upon you by your brother Trotun have multiplied like leaves on summer trees? What sheep did you have, what horses, what camels, before Joru came to bless them? Had he devoured half of them, you would do ill to chide him. Yet even now they are not countless. Check their numbers. It may be that you will find the back of Rongsa—who brought these tidings—more worthy of your lash than Joru's!"

Sanglun counted his animals and saw that of all their numbers, none were missing. He summoned Rongsa and beat him with the bridle of his steed. "Bearer of false tales! Lying rogue! Long before you came Joru kept my herds and they flourished and increased, until now they cover the whole mountainside. Had he slaughtered them as you have told me, their numbers would have grown less and not greater. You have an envious heart and a spiteful tongue. Keep guard upon them, Rongsa, for if you clack such mischief again, they will be torn out at the very roots!"

Joru said nothing, but Shikar laughed.

Now Sanglun resolved that he would return to the land of his fathers, and so he left the place where the three rivers meet, and journeying for nine days, he

reached the border of Nulumtala where his tribe dwelt.

Trotun saw the snow-white yurt and the flocks that stretched endlessly over the plain, and he galloped there to find Sanglun sitting before the door of his yurt with his three sons beside him.

"Greetings, Sanglun!" said Trotun. "Where did you get this fair yurt and the cattle that spread farther than eye can see on either hand?"

Joru answered, "Your folly, Trotun, is like the folly of the chip that does not know the rock from which it was hewn, or of the hound forgetful of his master. Because your brother, who never injured you, suffered evil at your hands, the gods have smiled on him and showered him with blessings."

"Your speech is bold, strange youth," said Trotun. "Since your spirit must match your tongue, I will give you a task. Go to the country of the seven alwins that devour every day the flesh of seven hundred men and beasts. Say that Trotun has sent you as a morsel for their delight, and take your mother with you, that they may feast the more abundantly."

"I will do your task, Trotun," Joru answered.

But Amirtasheela wrung her hands. "What folly is this, my son?" she cried. "I thought you were ripe in wisdom, yet now you would journey to the land of the seven alwins, so they may devour you. Go, if it be your

will, but as for me, I will stay here, and let the alwins devour whom they may!"

"No, mother, for if you perish at the hands of Trotun, will your death be sweeter?"

Then Shikar knelt in supplication before his brother. "I will go with you Joru, whether for death or for life," he said. "If it be for death, we will die together. If for life, I will live by your side."

Joru drew him apart and embraced him with tears of joy. "Now by your words I know you for my chosen friend and my heart's brother," he said. "I am Gesar, the son of heaven, sent by the Buddha to uproot the tenfold evil and restore gladness to the hearts of men. Yet until my fifteenth year has passed, I may reveal myself to no one but you. Therefore, be patient! Live with Sanglun and guard him from his wicked brother, but have no care for me, for death is not my purpose."

Joru loaded his mother's goods upon a yak, and journeyed with her to the country of the seven alwins. There he felled a sapling and fashioned seven magic wands from its wood. In a mountain cleft he caught seven hares and roasted them, and the wind carried their savory scent to the nostrils of the seven alwins. Presently the seven alwins rode into camp, with each alwin carrying on his back a hundred mortals and a hundred steeds. "What feast is this whose pleasant savor the wind has carried to our nostrils?" they asked.

19

Their voices were like the voices of lions that have been hungry too long.

Joru answered, "A feast no god would spurn— mountain hares and broth and sweet black tea. Please sit and eat, and lay aside for tomorrow the meal you carry on your backs."

The seven alwins did as Joru said and sat down to the feast. For seven days they ate and drank without ceasing, yet still the mountain hares lay whole before them and the caldron brimmed with tea. When at last they would have mounted their steeds, they had grown so heavy with feasting that the animals sank beneath their weight to the ground.

"Do not despair, you seven alwins," said Gesar, "for I will give you steeds to outrun yours as the wind outruns a camel. Mount these seven wands that I have fashioned of the wood of a sapling, and they will soar with you into the skies or pierce the mountains or bear you over the sea to distant shores. Where will you find horses of blood and bone to do such wonders?"

The alwins mounted the seven wands. "Reveal your wonders to us!" they cried. "Soar with us into the skies! Pierce the thick mountains! Bear us to the distant shores of the sea!" Lifting their heads, the seven wands soared upward and carried the alwins over flowering plains and shining rivers. When the wands reached the mountains, they pierced the rock

and issued forth beyond, and at length they came to the distant shores of the sea.

The alwins laughed for pleasure in their wands, and said to one another, "The youth spoke truly. These slender wands excel our steeds as the wind excels a camel. Now, having spanned the earth, let us cross the waters. Into the ocean, splendid chargers!"

Leaping into the ocean, the seven wands swam to where its depth cannot be fathomed, and there they flung the alwins from their backs. The seven alwins sank for seven days and seven nights into the dungeons of the dragon-princes who took them captive. But the wands returned to Joru and bowed before him to show him that their task had been completed. Joru loaded his mother's goods upon a yak. Then, driving before him the mighty steeds he had taken from the alwins, Joru set forth for home with Amirtasheela.

When they came to Trotun's yurt, they found a large company assembled to honor the wedding of Atlantu, his eldest son, with the Lady Kimsun. The feast was spread, and on one side the men regaled themselves, and on the other side the women. Trotun sat on his throne eating the forequarter of a sheep.

But no one welcomed Amirtasheela and no one welcomed Joru, and so they sat down on the ground, he amidst the men and she amidst the women, to await what would befall. The table was laden with all

manner of pleasant foods, and the wine flowed freely, yet neither food nor wine was offered to the wayfarers.

At length Joru cried, "Trotun! My uncle! A mountain of meat lies here and a river of wine! My happy eyes behold them but my unhappy gullet does not savor them! Trotun, I am hungry! Give me some of the forequarter clutched in your hand!"

Trotun answered, "I would give you some of the left shoulder, Joru, except that it is the symbol of my fortune! Or the right loin except that it is a charm to shield my daughters! Were I to give you the forequarter clutched in my hand, the evil of all evils would overtake me and I should be undone. Yet I would not have you utterly bereft. So, my Joru, take for yourself the tears of those who weep and the weariness of those who toil and die. Take the curse of the barren land that yields no fruit, and the carcasses of beasts dead of the plague. If these things do not suffice you, good nephew, then take sorrow and take venom and take death!"

Trotun released a wasp from his nostril and whispered in her ear, "Enter the nostril of my enemy and, creeping upward until you find his brain, pierce it with your deadly fang!"

But when the wasp would have entered Joru's nostril to pierce his brain, he fixed on it his eye that looked askance. As the wasp quailed before him, venturing

neither to the right nor to the left, Joru seized it and held it fast in his hand.

Straightaway Trotun fell down from his throne and lay upon the ground like one who had been stricken by the hand of death. But when Joru loosened his hold upon the wasp, he rose up again and bowed at Joru's feet. So Trotun fell and rose and fell again, as Joru alternately crushed the wasp against his palm and allowed it to breathe.

Altantu, knowing that his father's soul lay hidden in the wasp, asked the Lady Kimsun to plead with Joru to spare his life. She knelt before him, offering in one hand a turquoise as huge as the head of an eagle, and in the other hand a skin of wine.

But Joru frowned upon her and said, "What forward wench is this that kneels before me? It has always been the custom in Tibet for whoever weds with the son of a great prince to veil her countenance for three years and a day from the sight of all except her kinsmen. Even she who weds with a humble man will veil herself for three full moons. Yet here is one, pledged to Trotun's son, who bares her face to me on her bridal day. Is this wasp that I hold captive by chance your husband or your father or mother, that you sue so shamelessly for its life?" With these words, Joru turned his back upon her.

Then Atlantu prostrated himself, saying, "Joru! Kind Joru! God-protected Joru! Whoever, seeing you,

denies you bread, may his eyes be blinded! Whoever hears you ask for drink and heeds you not, may his ears be deafened! Whoever eats and will not give you any of his food, may his teeth rot in his head! Whoever holds a sheep in his right hand and offers you none, may his right hand be shattered! Now I pray you, Joru, release the wasp, and you shall wed the Lady Kimsun!"

Joru answered, "I may not wed the Lady Kimsun, but she shall be the bride of my brother Shikar, if she pleases him."

Joru loosened his hold upon the wasp, so that it fluttered in his hand. He said to Trotun, "Rise up and bow down before my mother whom you have wronged, and entreat her pardon."

Trotun bowed three times before Amirtasheela, entreating her pardon, and laid his forehead upon her feet.

Joru released the wasp and it returned to Trotun's nostril. Although Trotun then carried himself arrogantly as before, he dared not molest his brother Sanglun or Amirtasheela, for he greatly feared Joru's power.

CHAPTER TWO

JORU REVEALS
HIS TRUE IDENTITY

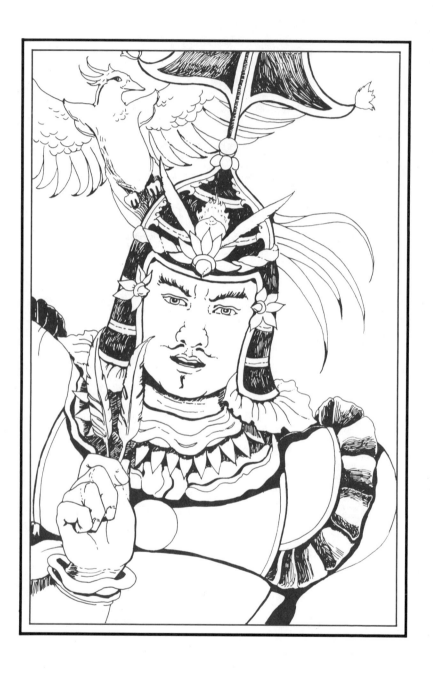

JORU REVEALS
HIS TRUE IDENTITY

*O*n a pleasant land that bordered on Tibet lived
Brugmo, daughter of King Sengeslu. So radiant
was her beauty that of all the princes of her
father's tribe, none was deemed worthy to be her
chosen mate.

She sought out her father King Sengeslu and said
to him, "I will journey to the land of Tibet and seek a
husband there, for men say it is a land peopled by
heroes and the sons of gods."

She journeyed to the land of Tibet, a wise lama
riding at her right hand, and a princely retinue follow-
ing after her. At her left hand rode the three peerless
archers and the three valiant knights who were her
champions.

In Tibet ten thousand chieftains gathered to wel-
come her, and she rode into their midst. "Lords of
Tibet!" she said. "I have come to choose a husband
from amongst you, for men say your land is peopled

27

by heroes and the sons of gods. That you may know me worthy to wed with the noblest, I will reveal to you the wonders that marked my birth. Though the skies grew black with clouds, the sun shone brightly among them; yet, when the clouds vanished and the heavens cleared, rains poured down out of the clear sky. A unicorn and a blue elephant paced round and round my father's dwelling, and a cuckoo sang above my mother's head, while on her right hand perched a parakeet and on her left a bird without a name. These are the signs of wonder that marked my birth. Therefore I have come among you to seek the hero destined to wed the Lady Brugmo.

"Six champions travel with me—three warriors whom the mightiest princes of our tribe have sought in vain to overthrow. The skill of these three bowmen is so great that when they have shot their arrows from the bow, a man may three times brew tea to quench his thirst before the arrows return to them. So truly do they aim that each one marks the spot where the arrow should strike by laying his head upon it, and only when the arrow plunges earthward does he turn his head aside to make a place for it. Such marksmanship as this my champions boast, and he that would wed me must excel it."

Having spoken, Brugmo galloped to the crest of a high hill that overlooked the field. From there she watched how the lords and princes of Tibet strove with her archers and her warriors. Yet each strove in vain.

She cried out in scorn, "Though you are heroes and sons of gods, yet you are powerless to overthrow my champions!"

Then Joru plucked the sleeve of the wise lama who rode at her right hand, and said, "I too would challenge Brugmo's champions, for though I am unseemly, my strength is as great as another's."

The wise lama answered, "Beware, my son. Do not venture your tender bones where mighty warriors have striven in vain."

"Though my bones be shattered into dust, still would I venture, Father."

"Then have your way and may Buddha be your shield!"

Joru's heavenly sisters, seeing his need, lifted him from the earth and set one foot upon a mountain top and one on the shore of the sea. Stooping, Joru seized the strongest of Lady Brugmo's warriors and hurled him over his head for a distance of a thousand leagues. The second he hurled two thousand leagues behind him, and the third and weakest, three thousand leagues. The people gazed in wonder upon Joru, who had done this deed.

Now he stood beside the archers of the Lady Brugmo. When she gave the signal, each warrior let fly his arrow, then flung himself upon the ground to await its coming. At midday three arrows returned

29

from their flight and plunged themselves into the ground where the heads of the three archers had lain but a moment ago. But the arrow of Joru did not return, for his sisters held it on Mt. Sumeru, decking the shaft with gaily plumaged birds as a sign to Joru of their love.

When at length they hurled it earthward, the birds spread wide their wings and hid the sun, so that darkness fell upon the face of the earth and men cried out, "The gods are angry! Disaster is upon us!" and would have fled in terror.

But Shikar lifted up his voice above the clamor. "Peace, foolish ones!" he cried. "It is Joru's arrow, which returns from its far flight!"

The singing shaft plunged itself into the earth where Joru's head had rested, and the gaily plumaged birds hovered above him, then soared, still singing, into the blue heavens.

The tribesmen shouted, "Hail to Joru, defender of the valor of Tibet!"

Trotun and the great ones who had been vanquished murmured to one another, "Though he is only a youth and ill-favored, with eyes that look askew, yet he has won the Lady Brugmo for his bride."

Brugmo descended from the crest of the high hill and looked upon the ill-favored youth who claimed her hand. She would have turned away in displeasure,

but Shikar held her fast and said, "You are fair, Brugmo, but you are a woman. Though he is as ill-favored as a goat, yet Joru is a man. Therefore, submit yourself as a woman should. Don't be forgetful so soon of your pledge to marry the man who could excel your champions!"

Brugmo could not but yield her hand to Joru. He pricked his finger with a blade and Brugmo drew the blood from his wound with her mouth. Plucking three hairs from the tail of his horse, Joru wove them together and tied them around Brugmo's throat.

"Thus I, Joru, plight my troth with you, Brugmo, the daughter of King Sengeslu!" Thus they were plighted for all to see.

But when night fell and the encampment slept, Brugmo stole away from her tent and roused her retinue. Together they took to their horses and galloped swiftly toward her father's realm. As they sped away, Brugmo cried out, "Who follows after us?"

The lama turned to view the plain and answered, "Nothing but the wind!"

They journeyed farther and again Brugmo cried, "Who follows after us?"

The lama turned again and answered, "Nothing but the silver shadow of the moon!"

31

They journeyed farther, and Brugmo said, "No, it is neither the wind's breath nor the shadow of the moon that lies upon my cheek! Look again, I pray you!"

The lama looked and saw that Joru, cloaked in darkness, sat behind her and clasped her in his arms. "The one who has won you for his wife sits behind you and holds you in his arms!" cried the lama.

Brugmo wept and beat her breast. "How can I hide my shame?" she said. "I who have spurned great lords and noble kings, how shall I bring my father this offspring of a camel to be his son? Alas, alas, I am lost beyond all hope!" Thus lamenting, she continued on her way, and Joru sat behind her, but said nothing.

When they were within a hundred miles of her father's kingdom, Joru caused a cloud of dust to rise before them as if from the hoofbeats of ten thousand horses. The great King Sengeslu, watching from afar, turned to his councilors and said, "It must be that our daughter has become the bride of China's glorious king!"

Now the cloud of dust grew less, as though a thousand horses drove it before them. King Sengeslu's joy diminished. "Though she has missed the mightiest," he said, "yet she returns the bride of some great lord whose name will be a crown of glory to us."

The cloud of dust grew less and less, until it was so small it might have been the herald of scarcely a hundred horses. King Sengeslu's face grew black with

foreboding, but he took heart again. "Trotun, a prince of fair repute, has won my daughter."

Surrounded by his chieftains, he made ready to welcome the Lady Brugmo and the man she had chosen from all the world worthy to be her mate. The cavalcade approached his yurt, and his daughter dismounted from her horse and bowed before him, weeping bitterly. Joru followed after her.

Her father looked upon Joru. "Is this the hero you have searched the world over to find?" he said. "Is this the god that has subdued your arrogance? Truly, my daughter, you have chosen a strange husband, but there is no one who will dispute your choice with you. Only beware lest the hounds howling at night mistake him for an abandoned carcass and so devour him!" Turning his back on them, he entered his yurt, but his knights encircled Joru and taunted him, prodding him with their spears.

Now in Tibet Trotun arose at dawn and saw that Joru had vanished from amongst them, and there was no trace of Brugmo and her retinue. He grew angry and summoned the great ones of the tribe. "Kinsmen and brothers!" he said. "Dishonor and shame will be yours if you sit idly by and suffer a beggar to enjoy the prize that should have been a prince's. Joru won the Lady Brugmo through guile and treachery, not in equal combat. Therefore let us go forth and free her from an unworthy mate!"

He spurred on his horse and galloped over the plain, and all the noblemen of his tribe galloped behind him until at length they reached the kingdom of King Sengeslu.

They halted before Sengeslu's yurt, and Sengeslu came forth amidst his councilors. "Where do you come from, strange warriors, and what is your will with me?" he asked.

They answered, "We come from far-away Tibet, where Joru strove against your daughter's champions and overthrew them. We would have you yield her up to us, for Joru is unworthy to be her husband."

"Though he may be unworthy, how shall I take her from him, since he met her challenge and overthrew her champions?"

"We did not come to reason with you, old man, but to hear your yea or nay. If you judge Joru too poor a thing to wed your daughter, then yield her up to us. But if you choose to cling to this treasure you have won, know that the princes of Tibet have brought destruction upon nobler heads than yours."

King Sengeslu was a just and righteous monarch, yet he feared the loud-mouthed strangers who menaced him and did not know how he should reply. He went apart with his ministers and took their council. Presently he returned to the princes of Tibet with his answer.

"You have spoken fierce words, warriors from afar, and I have heard you patiently. Now you hear me. Joru has shown himself your master in marksmanship and in the art of single combat. Yet he is graceless and mean of stature and ill-fitted to wed the Lady Brugmo. Therefore I decree a match among you. He whose steed will first bear him to the appointed goal shall take the Lady Brugmo for his wife. But if my decree offends you, then let us wage war upon one another, for no one shall persuade me from this course."

Trotun answered, "Let it be as you have decreed."

The edict went forth, and thirty thousand men gathered to contend for the hand of the Lady Brugmo.

Joru scattered incense and offered up a sacrifice to Kormuzda. "My father and father of the gods!" he said. "Let the brown wonder-steed descend, for I have need of him!"

Kormuzda answered, "He will descend, my son, yet not in splendor as you have known him, but as a misshapen horse of two years' growth. For it is not fitting that you should ride a godlike steed until you have revealed yourself as Gesar!"

When he had spoken, a whirlwind descended out of the heavens, invisible to all except Joru. When it touched the earth a horse of two years' growth stepped forth, and circled round and round, seeking

his master. When he saw Joru, he bowed before him and stood quietly.

Joru then climbed upon the horse's back and rode into the company of heroes. When they saw him astride his misshapen horse, they flung back their heads and laughed heartily.

But King Sengeslu spoke sternly to Joru. "Do you hope with this beast, as unsightly as yourself, to overtake the proud steeds of your rivals? Or is it your purpose to affront my daughter, unhappy as she is? Go take a stallion from my herds, and leave this stunted foal, lest you shame me beyond all measure in the sight of men."

Joru answered, "I will not take your stallion, swift-paced and ardent. I will run this match on my stunted beast and abide with the outcome."

King Sengeslu raised his hand, signaling the departure, and thirty thousand riders leaped forward and vanished from sight. But Joru, restraining his heavenly steed, was left behind until presently he loosed his hold upon him, and the brown wonder-steed in a single bound overtook ten thousand horsemen. Again Joru curbed him and again he set him free, and with a single bound he overtook another ten thousand horsemen. Yet a third time Joru held his horse in check, then let him go his way, and now he had overtaken all but Trotun's blue-black horse.

Joru said to his mount, "My little two-year-old that in three bounds has overtaken the glory of Tibet, when you come close to Trotun's blue-black horse, strike him with your forefeet and tumble both horse and rider into the dust."

The horse did as Joru told him to do, and with his forefeet struck the blue-black steed of Trotun and overthrew him. Trotun rolled in the dust, crying, "Alas Joru, what have you done to me?"

Joru answered, "Alas uncle, I know not, for I seek only to safeguard my treasure from thieves that would rob me, and your blue-black steed has stood in my way." So saying, Joru galloped past Trotun and reached the goal.

King Sengeslu proclaimed, "Joru has won my daughter a second time."

But the princes of Tibet murmured together and they went before King Sengeslu and said, "Truly Joru has reached the goal before us all, and therefore he may be accounted a skillful horseman. But he that slays the Wild Boar of the Wilderness and brings you his tail fashioned of thirteen strands for a sign, that one you will know as a hero, marked by the gods and worthy to wed the Lady Brugmo."

King Sengeslu decreed that he who slew the Wild Boar of the Wilderness should wed the Lady Brugmo. Thirty thousand chieftains sallied forth to hunt him,

but Joru was the first to come upon him where he bellowed in the forest, lashing his mighty tail and felling a hundred oaks at every blow. Joru took aim and sped his shining arrow swiftly to the wild boar's heart and slew him.

As he was about to sever the tail, made of thirteen strands, Trotun saw him and hailed him with honeyed words. "Now is the lady yours, good nephew, beyond a doubt, and no one will take her from you. Therefore, give me the wild boar's tail and I will tie it to my bridle and bear it before the people as the herald of your valor, crying 'Joru, my kinsman, has slain the Wild Boar of the Wilderness!' Thus I will share your glory, never again chiding you or using you ill, but cherishing you more tenderly than my own children."

"Take the tail, good uncle, for it is nothing to me!" Joru severed the tail from the wild boar's body and gave it to Trotun, but did not give it all to him, secretly hiding three strands.

Trotun galloped joyfully to the meeting-place. "Nobles and heroes!" he shouted. "Leave the hunt and pursue the chase no longer! For I, Trotun of Lik, have slain the Wild Boar of the Wilderness. I have tied his tail, made of thirteen strands, to the bridle of my stallion, and I claim the Lady Brugmo for my wife."

But Joru followed behind him and cried out, "Alas, you faithless one, did you not come to me when I had slain the boar and pray that I might give you the tail?

Did you not say, 'I will proclaim you victor and share your glory?'"

"What villainy is this, you wry-eyed knave? Do you think you can take what I have won from me by your faithless railing and false oaths?"

"Do you say so, Trotun? Then show me this tail, made of thirteen strands, that you took from the wild boar as a sign of your victory!"

Trotun drew forth the tail and held it up in triumph, but soon his joy turned to dismay, for he saw that the tail, made of thirteen strands, had only ten strands, and that three strands were missing.

"Did I not know you for a shameless liar," said Joru, "and did I not therefore withhold from you three strands of the mighty tail when in the forest you entreated me to give it to you?" With these words Joru drew forth the missing strands. Shamed before the multitude, Trotun turned his horse and galloped away in haste.

But now there rode out of the wilderness a horseman whose mount was flecked with foam. His eyes shone like the eyes of one who has seen a god, and his lips carried news of wonder. He cried out, "Lords and princes, following the wild boar's track through the wilderness, I heard the song of the Garuda Bird. Gazing upward, I saw her where she sat in a tall pine, preening her golden plumage."

39

King Sengeslu commanded his soothsayer to come before him. "Read me this omen!" he said.

The soothsayer read the omen and answered, "It is the voice of heaven that bids you give your daughter to the one who will pluck a golden feather from the tail of the magic bird, for no one may pluck it forth except by the will of the highest gods."

King Sengeslu made known the word of the soothsayer to the heroes assembled before him, and they rode into the wilderness to see if they could pluck the golden feather from the Garuda Bird's tail.

Joru remained behind at the camp for a brief time, then followed after the warriors. When he came upon the warriors, he found them gathered together at the foot of a tall pine, their arrows beating about the head of the Garuda Bird like silver rain. But the Garuda Bird, unheeding of their arrows, sat upon the topmost branch, uttering her strange cry and preening the golden feathers of her tail.

Joru spoke to her, saying soft words of praise. "Proud bird! How sweetly your voice soars above all others in this forest! Even so does your bright plumage outshine the plumage of all other birds! Would that we might gaze upon you in your glory!"

The breast of the Garuda Bird swelled with pride, and she walked out on the branch for all to gaze upon her. She lifted and lowered her mighty wings and

turned her stately head from side to side, flaunting her beauty.

Joru said, "In truth, you are as radiant as the sun breaking through storm-clouds. But what of your flight, O gracious bird of heaven, for surely when your wings carry you above the earth, you are like some god descended from Mount Sumeru to dazzle the eyes of men with his splendor."

Hearing these words, the magic bird spread wide her wings and floated above the trees as serenely as a cloud in a clear sky. But Joru said, "Draw nearer, blessed bird, so we may bow before your majesty!" She drew nearer. Blinded by her beauty, all the people veiled their eyes in dread before her, but Joru put forth his hand and plucked two golden feathers from her tail. Then Garuda Bird uttered a piercing cry, soared up into the heavens, and disappeared.

Joru, paying no attention to those that pressed about him, rode to the meeting place with the chieftains of Tibet riding close behind him. When he came to where Brugmo sat among her maidens, he told her to rise, and into her headdress he bound the Garuda Bird's golden plumes.

As he did so, the sky darkened, and the gods, arching their bows, sped shafts of flame to the four corners of the heavens. The voices of their dragon-steeds thundered across the blackness, and from the streams and rivers great floods were loosed upon the

people, beating them to the ground. Loud above the din, a cry rang forth: "The gods have triumphed! Evil is overcome!"

When the darkness lifted and the floods ceased, a wonder stood revealed. Where Joru had sat astride his misshapen horse, a warrior, mounted on a lordly steed, towered above them. His face was like the face of one beloved of Buddha; his chest was like the chest of the mountain gods, and his thighs were like the thighs of the dragon-princes that live beneath the sea. His armor was fashioned of seven jewels that sparkled like the dew at dawn, and a helmet wrought of the woven light of the sun and moon adorned his noble head. At his side he bore a lightning-sword three fathoms long. An ebony bow was girded about his shoulders, and from his quiver thirty silver arrows, notched with turquoise, raised their bright heads. Shikar, arrayed in splendor, was mounted beside him and thirty shining heroes surrounded him.

The warrior lifted up his voice and cried, "Heedless ones! Men of little worth! Know me for Gesar, the son of heaven, sent by almighty Buddha to be your lord, that the tenfold evil may be uprooted and gladness restored to the hearts of men!

"For fifteen years I have lived amongst you in the guise of Joru, for thus it has been decreed. Yet when I journeyed into the country of the seven alwins and drove them beneath the sea, did I not reveal myself as

42

a doer of mighty deeds? When I seized Trotun's soul in my hand and was like to destroy him, could you not see in me one marked by the gods? When, with one foot on the mountaintop and one on the shore of the sea I hurled the warriors of the Lady Brugmo over my head; when I vanquished her archers and my arrow returned from the skies decked with birds of gay plumage; when on a stunted nag of two years' growth I overtook the chargers of twenty thousand men, reaching the goal before them; when I slew the Wild Boar of the Wilderness and plucked two golden feathers from the Garuda Bird's tail—you blind ones with erring ways, though I was graceless and mean of stature, with eyes that looked askew, were these wondrous signs and portents no more to you than snowfall in winter or the braying of a wild ass on the mountainside?

"Bow down before me, for I am Kormuzda's son!

"Bow down before me, for I am the servant of Buddha!

"Bow down before me, you princes and tribesmen and beggars, for I am the light of your darkness, the food for your hunger and the scourge of your evildoing! I wield the sword of righteousness in one hand! Let my foes beware of its edge! I bear the balm of peace in the other! Let my friends savor its sweetness! The lama of lamas is come to judge among you! Bow down before him! The prince of warriors is come to lead you

to battle! Bow down before him! The all-conquering, all-healing Gesar is come to dwell in your midst! Bow down before him, you men of earth, and pay him homage!"

All the people bowed down before him in awe and wonder.

Brugmo was the first to raise her head. When she beheld the glory of Gesar, she laughed aloud and then she wept for joy.

CHAPTER THREE

JOURNEY TO CHINA

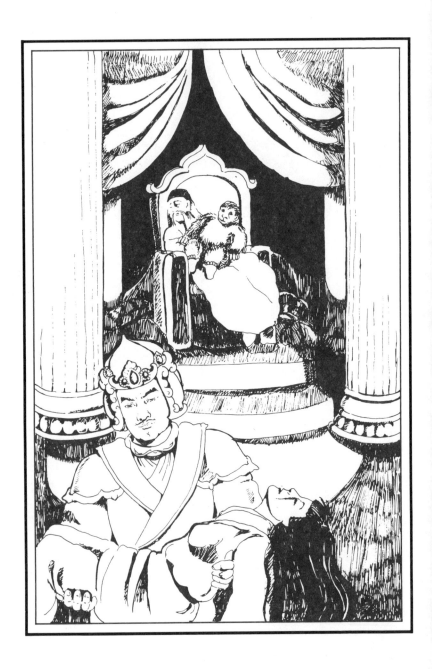

JOURNEY TO CHINA

It happened that the wife of China's lord, the noble King Keeme, sickened and died. Upon her death, the king's grief was so great that he would not be comforted, and he sent his criers forth into the land to proclaim his word:

"Disaster and woe are our lot! Therefore let anyone who hears this sorrowful news as he journeys, journey forever, mourning the queen. Let one who is at home mourn her at home, and never cross the threshold of his house again! Let one who feasts still feast and weep for her, and one who fasts not cease from fasting and lamentation. Thus shall her memory be honored forever!" The king sat upon his throne, holding the body of his dead wife in his arms.

But his edict was hateful to the people, and they muttered against him, yielding reluctantly to his command. Finally his ministers assembled in council, and the chief among them rose up and said:

"My lords, the queen is dead. It is fitting for her body to be given to the flames and for the holy lamas of our land to read Buddha's word for forty-nine days above her ashes. Alms should be showered freely on all in want, the dowerless and the beggars. Then let the king dress in brocade and take another wife, so he may minister to the needs of his people and bring joy to their hearts. For is this queen the first to be summoned by death? And is there one of us who will not follow her hereafter? In truth, madness has taken hold of our king and folly counsels him. If you know the man who will comfort his grief and lead his spirit back to sweet reason, pray name him to me."

But no one could name the man, although for long hours they held counsel with one another.

Now there lived in the court of King Keeme a smith, skilled in his craft, but meddlesome and with a prattling tongue, whose bald head was constantly seen about the gatherings of the great. Learning what was afoot, he stood now at the door of the council-chamber, listening to those within. Having heard enough, he hastened home, where his good wife met him on the threshold of their hut.

He said to her, "The wits of these ministers move as nimbly as a sick elephant! All day they wrangle and still they cannot name the man who may bring comfort to the soul of King Keeme. Yet I—a humble smith—know that no one except all-healing Gesar, lord of the

48

ten great regions of the earth and Buddha's messenger, has the power to solace him."

His good wife answered, "You sinful baldhead! Man of little worth! Where the sages of the king are unsure, you would be wise! They falter, but you are as firm-footed as a wild ass before a precipice that will not see the dangers awaiting him! Go to your forge, bearer of idle tales, and hold your peace!"

When the smith saw that she would not support him, he pretended great anger and cried, "Rash woman, go about your business and don't meddle with me! My stomach is as hollow as a kettle drum, yet no fire is laid and no meal prepared. Fetch water from the stream and curb your railing tongue, or you will feel my staff about your shoulders!"

When his wife went to fetch water from the stream, the smith returned to the council-chamber and sought an audience. The chief minister allowed him to enter and said, "What is your suit?"

"My lords and ministers! Have you found the man who will heal the soul of King Keeme?"

"We have not found him. Can you name him to us?"

"That I can. Only one man has the power to do this deed: mighty Gesar, lord of the ten great regions of the earth, and Buddha's messenger."

49

"Your words are just, but he dwells in a far country. Who will move him to journey here to serve our need? Will you do the task?"

"Gladly, if you will give me a swift horse to ride, and a companion to lighten my way."

They gave him a swift horse and a companion to lighten his way. Setting forth, the smith journeyed for many months until he reached the mountains of Tibet and Gesar's shining yurt.

Now Gesar had knowledge of this smith and his errand, and when the smith came into his presence, Gesar fixed upon him a glance so baleful that the smith quaked in terror. His limbs would not bend beneath him or hold him upright, and he could move neither forward nor back nor bow in greeting, but only stand staring at Gesar with open mouth.

Gesar said, "What a blundering baldhead is this that seeks my presence! Can't you move or sit or bow to me in greeting? Will you stand there forever, your knees shaking like grain in a high wind? Where are you from? Why do you come before me?"

Still the smith could not utter a word. Gesar, taking pity upon him, removed his baleful glance and eyed him in friendliness. Only then did the smith regain his wits. He bowed down in greeting and said, "Dread son of heaven! The wife of China's noble lord has passed away. His grief is so great that he will not

cremate her body, but sits upon his throne holding her in his arms.

"Moreover, he has proclaimed: 'Let every man who journeys, journey forever, mourning the queen! Let one who lives at home mourn her at home, and never cross the threshold of his house again! Let one who feasts still feast and weep for her, and one who fasts not cease from fasting and lamentation! Thus shall the queen's memory be honored, and never perish from our hearts!'

"This is the edict of a fool, not of a wise king. Therefore the people mutter against him, and the ministers have sent me hither to entreat you to comfort our master and lead his spirit back to sweet reason. Well they know that no one but all-healing Gesar has the power to do this deed."

"What? Is it for this that I have come among you—to solace grieving kings who set their will above the will of the gods? Is this my mission?"

"I know not, master," said the smith quietly. "Yet if you deny us, there is no help beneath the heavens nor above the earth."

"I know you, smith, for one skilled in your craft, but meddlesome and with a prattling tongue, ever ready to butt your head into the gatherings of the great. You came here not to bring solace to your king

but so that your fellows might count you as a man worthy of mark. So prove your worth.

"For this task you have brought me, I need three treasures—a stag's horn filled with blood from the beak of an eagle, a goat's horn filled with milk from the breast of his mate, and a sheep's horn filled with tears from the eyes of his fledgling. Bring me these three treasures and I will travel with you to distant China to solace your king and restore peace to his kingdom. But if you do not bring these treasures after three days, you will be cast into a caldron: Your flesh will be flung to vultures and your skull made into a goblet for the least of my household to drink from."

Deeply distressed, the smith went forth from Gesar's presence, for he did not know how to accomplish the task he had been given. For two days he climbed about in the mountains and scanned the skies, casting his snare in vain. He wept and cried, "If only I were safe in my hut! Never again will I seek the councils of the mighty! I will stay at home, working from dawn to dusk, and listen to the prudent words of my good wife!"

As he spoke, sleep came to him, bringing a dream. "Go to the mouth of the Nyrandsa river, where you will find the carrion of a cow. Cast your snare there, and dig a pit and hide inside it. Then what has been foretold will come to be."

The smith awoke and went to the mouth of the Nyrandsa river. At the place where he found the car-

rion of a cow, he cast a snare and dug a pit and hid inside it, waiting to see what would happen.

Soon a black eagle flew out of the north, with his mate flying behind him, and their fledgling following behind them both. The black eagle circled above the carrion, and said to his mate, "I will go down and eat my fill of the carrion. No one is near to hinder me."

But his mate replied, "Do not go, my love. It is not right for a bird of the heavens to go down to eat the foul flesh that rots on earth. It is as monstrous as if some earthbound creature should soar aloft to share the skies with us. Do not go, I beg you."

"No, I will go, but I will be careful, looking around in every direction. If no creature moves, I will stay and eat, for I know the flesh of this beast is tender beyond my dreams. But if I see so much as a reed tremble, I will return to you right away."

He flew down, looking around in every direction, but he did not see anything, not even the trembling of a reed. He alighted on the carrion and ate, and so sweet was the taste of the flesh that he did not stop eating until he came at length to the breast. Then the smith leaped out of the pit, and drawing tight the strands of his snare, he captured the black eagle.

The eagle beat his wings in frenzy and struck his beak against his captor's staff so hard that blood flowed from his beak. The smith gathered the blood in a stag's horn, and put it down carefully in his sack.

The eagle's mate drew near with piteous cries, hovering about his head. "Alas, my husband, didn't I warn you of danger? Now you must eat the bitter fruit of your rashness and die in misery."

But the smith cried, "Not so, eagle's mate! Have I harmed your husband? As for the blood I have taken from his beak, it is only a little and will soon be renewed. Do you want to save your husband from death?"

"Yes, I do," she cried out.

"Then fill this goat's horn full of your milk, and in this sheep's horn gather your fledgling's tears. When you bring them to me, I will release your husband." The smith loosened the threads of his snare, so the black eagle could lift his head and flutter his wings before the smith tightened the snare again.

The eagle's mate took the goat's horn and the sheep's horn from the smith. She filled the goat's horn with milk from her breast, then chided her fledgling until he wept bitterly, and gathered his tears in the horn of the sheep. She brought the horns to the smith, who took them and released the black eagle. The three birds then soared up into the heavens and vanished.

The smith returned to Gesar and bowed in greeting. "What of your quest, bald-headed smith?" asked Gesar.

The smith answered, "The quest is ended, lord." He took the stag's horn and the goat's horn and the sheep's horn from his sack and offered them to Gesar.

Gesar took them and said, "You have done my bidding, and I will journey with you to China to solace your king and restore peace to your kingdom." So they set forth, and the smith rode beside the mighty Gesar, but his companion rode behind them.

When the three travelers came to distant China, they dismounted before the palace of King Keeme, and Gesar entered in. He passed through many chambers until he reached a hall of marble columns, with windows made of bronze. In each window a crystal was set, so the golden light of the sun might shine through. The ceiling was of silver and ivory and the walls were jewels that gleamed softly like the embers of a flame. At the end of the hall, on his throne carved from a great emerald, sat King Keeme, holding his wife's body in his arms.

Gesar said to the king, "Ill-omened is that dwelling, O king, where the living consort with the dead. Therefore do as your fathers before you, and deliver the body of your queen up to the flames, for her spirit

has passed away. Let the lamas assemble to perform the holy rites over the queen's ashes, and let alms be scattered among the needy. When this is done, take another wife, for it is not fitting for a king so mighty nor an empire so glorious as yours to lack a sovereign lady."

But Keeme answered, "This fellow babbles nonsense. I will not put my wife down after one year or after ten."

Gesar went forth from the hall of columns, and the ministers of the king bowed down before him. "Dread son of heaven! Glorious Gesar! Have you brought healing to our master?"

Gesar answered, "Your master's soul is sick unto death and no one can heal him."

But when night fell and King Keeme slept on his throne, Gesar stole secretly into the hall of columns and took the body of the queen from his arms and left an ape in its stead. The sentinel who stood watch over the king would have cried the alarm, but his tongue stuck to the roof of his mouth, and no sound came forth.

With the dawn King Keeme awoke, and the ape danced in his arms. But he flung it from him, crying, "Woe! Woe is me! Grievously have I offended against the gods, and they have punished me, transforming my wife into an ape."

56

But now the tongue of the sentinel was loosened, and he bowed down before his master. "No, mighty lord! He that men call the son of heaven, noble Gesar, stole into your chamber during the night and took the body of the queen from your arms and left the ape there instead. I tried to sound the alarm, but I could not, for my tongue stuck to the roof of my mouth, and no sound came out. Wherefore your servant deserves death at your hands, O dispenser of justice!"

"You shall not die," said the king. "The man who has done this deed shall die! Let him be cast into the Hole of Wasps, so they may pierce his eyes and harry him to death."

So Gesar was cast into the Hole of Wasps. But when the wasps swarmed about him and would have pierced his eyes, he scattered the tears of the black fledgling among them. Breathing in the odor that arose from these tears, the wasps died.

Gesar slept, but when the dawn came he lifted up his voice and sang, "The glorious king of China thought to slay me by casting me into his Hole of Wasps. Yet he must rejoice in the end that Gesar was not slain by his wasps, but his wasps by Gesar."

The Keeper of the Hole of Wasps went to King Keeme and reported Gesar's words. The king frowned and said, "Let him be cast into the Pit of Serpents, so they may dart their venom into his body and destroy him."

Gesar was cast into the Pit of Serpents, but when they would have darted their venom into his body, he scattered the milk of the black eagle's mate among them. Breathing in the odor of this milk, the serpents died. Gesar strewed the serpents about the ground to make a couch to lie upon, and the largest of them he laid beneath his head for a soft pillow.

And so he slept. When the dawn came, Gesar lifted up his voice and sang, "The illustrious king of China sought to slay me by casting me into his Pit of Serpents. Yet he must rejoice in the end that Gesar was not slain by his serpents, but his serpents by Gesar."

The Keeper of the Pit of Serpents hastened to King Keeme and reported Gesar's words. The king's face darkened in anger, and he thundered, "Let this blasphemer be cast into the Den of Wild Beasts, that they may tear his limbs apart and devour his flesh down to the last morsel."

And so Gesar was cast into the Den of Wild Beasts. But when they would have fall upon him to tear his limbs apart, he scattered the blood of the black eagle among them. Breathing in the odor of the eagle's blood, they soon died. Gesar then stripped the skin from the mightiest tiger and fashioned from it a saddle for his brown wonder-steed.

When the dawn broke, Gesar lifted up his voice and sang, "The exalted king of China sought to slay me by casting me into his Den of Wild Beasts. Yet he

must rejoice in the end that Gesar was not slain by his wild beasts, but his wild beasts by Gesar."

The Keeper of the Den of Wild Beasts fled trembling to the palace and reported Gesar's words to King Keeme. The king rose up from his throne, a storm raging in his countenance. "Let this doer of evil and speaker of idle words be brought to the ramparts, where twenty-four spearsmen will mete out to him the vengeance of the king!"

Gesar was then led to the ramparts. As he walked along the stone walls, a red parrot alighted on his hand. He attached to her leg a silken thread a thousand fathoms long, so slender that it was invisible to all except him. When he came to the ramparts, twenty-four spearsmen surrounded him, and the king stood before them to give the signal.

But Gesar lifted high the hand on which the red parrot was perched, and cried aloud, "Fly swiftly, my parrot, to Tibet, and seek out Shikar my brother, and my thirty heroic companions, and the three hundred chieftains of the tribes. Say to them, 'The king of China has foully slain your lord, whom Buddha sent to uproot the tenfold evil and bring you peace. March therefore at the head of all your hosts into his kingdom and ravage his green fields, scatter his people, and burn their homes. When you have wreaked havoc on every hand, contrive for him a shameful death, so that his transgression against the gods and against Gesar may be atoned.'"

So saying, he released the parrot, who vanished from sight, but the silken thread he did not release, binding it to his wrist.

The king pondered for a long time on Gesar's words. The ministers whispered to one another, and in the end the chief minister bowed down before his master and spoke:

"O righteous king! Three times you have condemned this Gesar to bitter death, yet not the wasp's sting nor the serpent's fang nor the jaws of the wild beast have prevailed against him. Surely it is a sign that the gods cherish him above all men, and will not suffer evil to approach him or those that follow him. How then shall we subdue Shikar his brother, or his thirty heroic companions, or the three hundred chieftains of his tribe? Their hosts will descend upon us and sack your cities and destroy your people, leaving behind no trace of all your glory. Wherefore we pray you, whose wisdom is as the never-failing mountain stream, bid Gesar recall his parrot, and pledge him in return whatever boon lies nearest his heart."

King Keeme answered, "My ears are open to the prayers of my people. Gesar, lord of the ten great regions of the earth, recall your parrot, and whatever boon lies nearest your heart, ask and it shall be granted to you."

But Gesar said, "Alas, son and sire of kings, I would do your will, but this parrot has flown beyond the sound of my calling."

Then the people flung themselves at Gesar's feet, loudly entreating him, and King Keeme added his voice to theirs.

"I pray you, noble Gesar, dread son of heaven, chosen of the gods, recall your parrot, and whatever you command me, that I will do though the Fearful Ones themselves forbid it."

"Will you give the body of your wife to the flames, and take another wife?"

"Even as you say."

"Will you give me your daughter Aralgo, the maiden whom men call Ten Thousand Joys, to be my second wife?"

"That I will do also, and count it a blessing on my house."

Then Gesar lifted up his voice and cried, "Fly back, my parrot, for the words you carry to Tibet are idle words, and not to be regarded."

He drew toward him the silken thread a thousand fathoms long, and out of the western sky the red parrot flew swiftly toward him and alighted once more on his hand.

King Keeme then gave the body of his wife to the flames. For forty-nine days the lamas read the holy word of Buddha over her ashes, and alms were scattered freely among the needy. The king took another

wife and bestowed upon Gesar the hand of Aralgo, his daughter, the maiden whom men called Ten Thousand Joys. A great feast was spread, and gongs were sounded in the streets and drums beaten, for the people rejoiced that Gesar had brought healing to the spirit of King Keeme. And the bald-headed smith was invited to the feast, and sat on Gesar's left side.

For three years Gesar lived in China with Aralgo, but when that time was spent, he said to her, "I have healed your father's grief, and for three years I have lived with you in the land of China. Now my heart hungers for my people in Tibet, and for the Lady Brugmo, appointed by the gods to be my wife. Therefore I will return to my country, and you will ride with me until we come to the Valley of Pleasant Winds, which lies a month's journey from Tibet. There you will dwell on the sunny hillside, and I will give you copper vessels and household goods and flocks of beasts, and vassals to do your bidding. You shall be mistress over all these treasures, if you will pledge your constant faith to me."

Aralgo, the Lady of Ten Thousand Joys, pledged Gesar her constant faith, and they took leave of King Keeme and set forth on their way.

When they came to the Valley of Pleasant Winds, they saw an attractive yurt standing on the hillside, and flocks grazing in the pastures. Gesar said farewell to Aralgo, and journeyed farther.

Presently he came to a high mountain, and looked down upon the world from its summit. A great weariness came upon him, and he cried out, "Mighty Kormuzda! I have labored for many months, and have brought about many excellent deeds for the glory of your name! Now I am weary and would stay for a while upon this mountaintop and regard the world."

But his three sisters appeared to him and said, "Beloved brother! Your head is like the head of Buddha, your chest like the chests of the mountain gods who sit on the four peaks of Sumeru and guard the earth; your loins are like the loins of the dragon-princes that dwell beneath the sea. Whoever your staff chastises is cleansed of sin; whoever your hand slays is purged of his unrighteousness. Are you not Gesar, Kormuzda's son, lord of the ten great regions of the earth, and Buddha's servant? What loftier destiny do you hope to earn by resting on the summit of this mountain and regarding the world?"

"My sisters counsel wisely," Gesar said. "We tarry here, me and my brown horse, not to regard the world, but to refresh our weary limbs." And Gesar went down the mountain and journeyed farther.

He sent a dream to Brugmo, who slept beneath a sable skin in her yurt. The dream said, "Brugmo! Your nose lies buried in your sable skin like the nose of a red calf in a deep meadow. It would be more fitting for you to rise at daybreak and frolic like a fawn on the mountain peak, for Gesar, your lord, is close at hand."

Brugmo arose and dressed in bright garments, and called out to her servant Arigon, "Brave Arigon! Your master and my beloved lord is close at hand. Hasten, therefore, to make sweet black tea, so he may satisfy his thirst and comfort his weariness, for he journeys from afar."

But Arigon answered, "Truly, my mistress, your body is like a jeweled treasure-box, rich in beauty, but your thoughts are like shreds of rubbish lying within. My body is as unlovely as the belly of an old horse, yet my thoughts adorn it with the rarest of silks. Do you think to content the mighty Gesar, who returns again to his people after a long journey, with a cup of tea? Take shame upon yourself, fair Lady Brugmo, for such a welcome, and learn your duty from me.

"Let a swift messenger ride to the source of the Lion's Stream, where Sanglun lives with Amirta-sheela, and bring them the news that Gesar is at hand. Let another ride to the Stream of the Elephant, where Shikar awaits his brother's coming. Let the thirty heroes be summoned, and the three hundred chieftains of the tribes, so that they may greet their master with worthy gifts. Let a feast be spread of roasted oxen and mountain hares and sweet black tea, while cymbals crash and kettledrums are beaten to honor the return of Gesar."

Brugmo answered, "Your words are as full of light as the noonday sun. Go and order all things just as you have unfolded them to me."

Arigon did as she told him. From the Lion's Stream Sanglun came riding with Amirtasheela, and Shikar galloped from the Stream of the Elephant, laughing with joy. The thirty heroes and the three hundred chieftains of the tribes assembled with gifts to greet their master. A feast was prepared of roasted oxen and mountain hares and sweet black tea, while cymbals clashed and kettledrums were beaten to honor the return of Gesar. Brugmo stood at the threshold of her yurt to welcome him.

He approached on his brown wonder-steed and, dismounting, he embraced Brugmo and Shikar, his brother, and his mother Amirtasheela, and Sanglun. The thirty heroes and the three hundred chieftains of the tribes offered him gifts of animal skins, and weapons cunningly wrought, and horses that were as blue as turquoise and as red as ruby and as black as the darkest night.

For thirty days they feasted, rejoicing that their lord had come again to live in the midst of his people. Then they returned to their tribes and dwelling places, while Gesar lived among them and ruled them wisely according to the law of Buddha.

CHAPTER FOUR

VALLEY OF PLEASANT WINDS

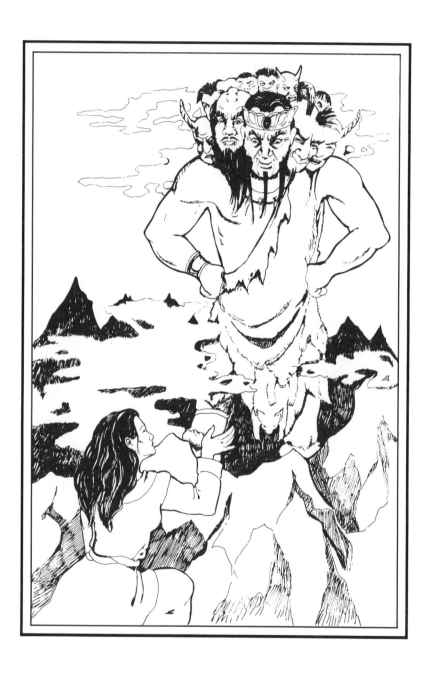

VALLEY OF
PLEASANT WINDS

*A*ralgo, the Lady of Ten Thousand Joys, lived
in the Valley of Pleasant Winds that lay a
month's journey from Tibet. The wily
Trotun, learning of her hidden valley, mounted his
russet mare and traveled to that place. Trotun came
upon Aralgo as she stood at the threshold of her yurt,
eyeing her flocks.

"Fair kinswoman!" he cried. "Your upward glance
stirs wonder in the hearts of ten thousand men, while
your downward glance stirs joy. Yet he who names
himself lord of the ten great regions of the earth has
forsaken you and takes his ease by Brugmo's side,
leaving you desolate. If your faith were pledged to me,
O lovely one, I would not so offend you. I would set
you above my lesser wives, and you would rule my
household and order all things according to your
desire."

"Alas, great prince, what evil you speak! May the
ears of all who have heard your words be deafened!

May their eyes burst from their heads! Bear me witness, blue heavens, bear witness, mother earth! That if ten thousand Trotuns came to woo me, they would be to me less than the very shadow of my Gesar. Now come within, Prince Trotun. Eat and drink, then go your way in peace."

Trotun entered the yurt, and Aralgo placed delicious food before him. Having eaten the food and drank the sweet tea, he then went on his way.

But after seven days he returned to the Valley of Pleasant Winds and said to Aralgo, "Maiden whom men call Ten Thousand Joys, Gesar has cast you off. Wherefore I pray you, lay your hand in mine and pledge your faith to me."

Aralgo answered, "How lightly you regard the words I gave you seven days ago, Trotun. It cannot be that you speak the will of my lord, for I have often heard him call you a shabby fellow, of little worth. No, you alone have offended me and you alone shall pay the penalty."

She called to her vassals and herdsmen. "Beat this Trotun soundly with your staffs and drive him out of the Valley so he may never return again!"

They fell upon Trotun and beat him with their staffs until their arms grew weary. They took his russet mare and drove him out of the Valley on foot. So grievous

were his hurts that he did not make his way home to Tibet for three full months.

But when his wounds had healed, he thought how he could avenge himself upon the Lady Aralgo. He girded his weapons about him, packed food for a hundred days, and went to the Cavern of Curses.

There he bowed down and said, "Spirit of the Cavern, that lends guidance to all who ask, whether for joy or sorrow, come to me in a dream and reveal to me how I may wreak vengeance upon Aralgo, who has wronged me."

For three times thirty-three days Trotun sat before the Cavern of Curses, awaiting a sign, but the spirit of the cavern was mute. At length he cried, "Do you lack power or will, O silent Cavern, to lend me guidance? For I, Trotun, have waited ninety-nine days upon your pleasure. My bag is empty of food and my soul of patience, and still you have made no sign. Would you have me die of hunger, unfeeling spirit, before your very gate?"

In the night the spirit of the cavern appeared to Trotun in a dream, and revealed to him how he could wreak vengeance upon Aralgo, the Lady of Ten Thousand Joys.

Trotun returned to the Valley of Pleasant Winds. Seeing him from a distance, all the herdsmen—the shepherds and cowherds, the herders of horses and

camels–gathered their flocks together and placed themselves in their midst.

Trotun came near and called out, "How do your flocks fare, good herdsmen? Do their numbers increase or decrease from day to day? Do your beasts grow lean or fat?"

Their leader answered, "What is it to you, Trotun, if our flocks increase or decrease from day to day? Will you reward our care if they grow fat or flog us for their leanness?"

Trotun cried, "Death for your insolence!" and raised his hand to strike. But the leader of the herdsmen rallied his men about him with loud shouts and clamor. "Come, all who serve the Lady Aralgo!" he cried. "Trotun has come to rob us of our herds and carry away our mistress!"

They surrounded Trotun and beat him with their staffs, but their blows fell harmless about him, for he was guarded by the spirit of the cavern whose aid he had invoked. Finally, the herdsmen released him and drove him forth again from the valley.

When night fell, he stole to the marshland where the swineherds tended their swine, and questioned them. "Are you content with your lot, you swineherds of the Lady Aralgo?"

They answered, "Why, is there anything pleasurable in our lot that we should be content? The cow-

herds and the shepherds pasture their flocks in pleasant places, while those who guard the camels and horses gallop at will to far-off fields and distant mountains. We alone of all the herdsmen must live in this foul marsh, though the rains drench us, the droughts parch us, and the winds pierce us to the bone."

"Yours is truly a miserable life!" Trotun said. "Do you wish to be uplifted above your fellows and blessed beyond all men?"

"That we would."

"Then do as I say, and the cowherds and shepherds, and those who guard the camels and horses will bow down before you, and no one in all the tribe shall be higher than the swineherds of Lady Aralgo."

The swineherds in their folly listened to Trotun's false words. "What is your will?" they asked. "Tell us and we will do as you say, so that we may be exalted above our fellows."

Trotun revealed his will to them and departed from the Valley of Pleasant Winds.

At midnight when the candles were put out, the swineherds filled three wooden troughs according to Trotun's instructions: the first with blood, the second with brandy distilled three times, and the third with sour milk. They set them down before Aralgo's door, and cried, "Mistress, awake! The cows suckle their young!"

Aralgo awoke and asked, "How many cows?"

They answered, "A hundred cows suckle their young."

Aralgo replied, "It is well," and slept again.

But scarcely was she asleep again when the swineherds cried, "Mistress, awake! The cows suckle their young!"

And she awoke and cried, "How many cows?"

They answered, "A thousand cows suckle their young!"

Aralgo replied, "It is well," and slept again.

But now the swineherds clamored once more before her door, crying, "Mistress, awake! The cows suckle their young!"

She awoke and asked, "How many cows?"

They answered, "All the cows suckle their young."

Aralgo leaped from her couch, crying, "My people will lack milk," and quickly went outside. But as she crossed the threshold of her yurt, she overturned the wooden troughs and poured upon the earth the blood, the brandy, and the sour milk. Their noxious fumes mingled together and were borne by an unfriendly wind into Tibet.

Immediately the people of Tibet were stricken with disease and pestilence, and Gesar was the one most seriously afflicted. Brugmo went to the soothsayers and said, "Sages of Tibet! Our people are stricken with disease and pestilence, and Gesar, our lord, droops on his couch with some strange malady. Read me your signs, you from whom no mystery is hidden, and say where this fearsome sickness comes from."

The soothsayers took the red threads of prophecy and read the signs. "It is a sickness borne here from the Valley of Pleasant Winds, the home of the Lady of Ten Thousand Joys, whom Gesar took to be his second wife."

Brugmo questioned the soothsayers, "How shall we subdue it, so that Gesar and our people may be healed of their affliction?"

"Neither Gesar nor our people will be healed until Aralgo is driven forth from her dwelling-place, for the curse laid upon her is a bitter curse, boding disaster. Our magic has no power to destroy it."

Brugmo sent two messengers to the Valley of Pleasant Winds and told them to say to Aralgo: "The evil that has come upon our people and Gesar, our lord, proceeds from you. Therefore depart from this place and go where you will, so that Gesar's strength may be restored to him, and the curse lifted that has been laid upon our people."

When the messengers brought this message to Aralgo, she questioned them, saying, "Is it Gesar, my lord, who drives me forth, or do you bring the word of Lady Brugmo or the vile Prince Trotun?"

The messengers answered, "It is Gesar who drives you forth."

Aralgo's eyes flashed with anger, and she said, "You lie, false knaves! Why should my beloved Gesar betray me, when I have kept faith with him? No, you are sent by Trotun or the Lady Brugmo, and not by Gesar, whose strength may the gods swiftly restore to him! Return then to those you serve and say: 'Aralgo bows to your will, but the sorrows you have sown for her today, you shall reap yourselves tomorrow!'"

Alone and unbefriended, Aralgo left the Valley of Pleasant Winds. She wandered up and down the face of the earth, not knowing where to seek shelter.

Presently she came to a strange country whose trees and streams, mountains and flowering meadows were as white as ivory. A white hare bowed down before her and said, "You are destined for our master," and led her to the border of his land.

Having crossed the border, she found herself within a kingdom whose trees and streams, mountains and flowering meadows were as blue as turquoise. A blue wolf bowed down before her and said,

"You are destined for our master," and led her to the border of his land.

Having crossed the border, she came to a realm whose trees and streams, mountains and flowering meadows were colored with the rainbow's changing hues. A magpie bowed down before her and said, "You are destined for our master," and led her to the shore of a dark sea. Now a burning wind swept over her, scorching her with its flame, and now an icy blast descended upon her and beat her to the ground. When she tried to stand up, she could not, so fiercely was she buffeted on either side.

She cried out in terror, "Protect me, gods of my father! Protect me, Gesar, whom I never wronged!" Then the darkness lifted and the winds stopped blowing. Standing before her, Aralgo saw a creature with twelve heads. On each head the upper lip ascended to the skies, while the lower lip hung downward and touched the earth. Aralgo knew he was the twelve-headed giant, and guile entered her heart.

"What creature are you whose splendor dazzles my sight?" she said. "Are you Kormuzda, father of the gods? Are you the proudest of the dragon-princes? Or can it be that I have reached the goal of my wandering, and found the very one I seek?"

"Whom do you seek?"

"The giant with twelve heads."

77

"What do you want of the giant with twelve heads?"

"Know, radiant being, that when Gesar, lord of the ten great regions of the earth, withdrew his favor from me, I vowed to journey up and down the land until I had found the giant with twelve heads. I want only to be his slave, to milk his cows or clean the ashes from his hearth. I would perform any humble task, so long as I might live in the shadow of his glory."

The giant bellowed with laughter that shook the mountains and troubled the waves of the sea. When his laughter was spent, he said, "Truly, your words are as pleasant to my ears as the sound of breaking bones, and I have no wish to harm you. Many times I have heard your beauty praised, and many times thought to take you for my wife. Yet Gesar, your lord, is a foe not to be challenged lightly, so I have left you unmolested upon your hillside. But now that you have come freely into my kingdom, no one shall take you from me, not even Gesar himself. Nor shall you be my slave, to milk my cows or clean the ashes from my hearth: You shall be my cherished wife and mistress of my household."

So saying, he seized her under his arm and carried her away to his castle on the summit of the highest mountain. There he told her to wait for him in the courtyard of the castle. He entered the castle, and as his wives came forth to greet him and bowed before

him, he devoured each one in turn until only two or three remained. Then, summoning his vassals together, he said, "I proclaim the Lady Aralgo my cherished wife and mistress of my household." He led Aralgo to his ebony throne and seated her beside him.

Thus did the Lady of Ten Thousand Joys break faith with Gesar, and plight her troth to the twelve-headed giant.

Now the people of Tibet were freed of disease and pestilence, and Gesar rose from his couch, restored to strength. He spoke to Brugmo, saying, "Beloved wife, I have laid suffering upon my couch for a long time. Many months have passed since I brought Aralgo from China and left her in the Valley of Pleasant Winds. Now I will go there, lest she should weep for sorrow that I have forsaken her. Let my brown horse be saddled for the journey!"

Brugmo answered, "Your command, O destroyer of the roots of evil, is like the command of the Fearful Ones, swiftly fulfilled. Yet why do you saddle your brown horse, since she whom you would comfort has left the Valley of Pleasant Winds, and gone who knows where?"

Gesar was troubled by this news. He summoned Shikar, the thirty heroes, the three hundred chieftains of the tribes, and his uncle Trotun, and questioned them. "Which of you can tell me where Aralgo has

gone from the Valley of Pleasant Winds, so that I may go in quest of her?"

Shikar and the thirty heroes and the three hundred chieftains of the tribes were silent, but Trotun stepped forward and spoke.

"Son of the everlasting gods, Trotun will answer you. Because she thought you had forsaken her, the Lady of Ten Thousand Joys left the Valley and lives, men say, with the twelve-headed giant. Therefore do not spend your strength in vain journeyings, but stay with us, and grant yourself and your horse the blessing of sweet repose."

"Sage counsel from a fool, uncle Trotun! If my wife has gone freely to the twelve-headed giant, I will find her and slay her, so that her sin against me may be atoned. But if the giant has taken her by force, then I will slay the giant and take my wife back to the Valley of Pleasant Winds."

When the lamas and holy men learned of Gesar's purpose, they counseled him against it. "Do not forsake us, you who have brought light out of darkness, for the stars frown upon this enterprise."

Gesar answered, "Wise lamas consider how they may redeem the souls of men, and foolish ones how they may fill their bellies without toil. But when you would give counsel to Gesar, you are like two calves bound to a tree, beating your head against your

fellow's flank. Observe your vows and fast, pious ones, and go your ways."

Now the ministers approached and bowed before him and said, "Do not forsake us, you who have brought peace out of confusion!"

Gesar answered, "While I am gone, administer the law I have given you, and judge not by a man's appearance, but read his heart."

Then the three hundred chieftains of the tribes bowed before him and cried, "Do not forsake us, beloved of the gods, you who protect us against all enemies."

Gesar answered, "It may be that our enemies prepare even now to march against you and give you battle. Return then to your tents, and look to your armor and your helmets, lest they lose their luster, and to your weapons, lest their edge be dulled."

Heeding their lord's words, the lamas and ministers and the three hundred chieftains of the tribes departed from Gesar's presence.

Then Gesar put on his armor that sparkled like the dew at dawn, and his helmet wrought of the light of the sun and moon. He girded about him his lightning sword three fathoms long, and his ebony bow, and his thirty silver arrows notched with turquoise. His magnificent brown horse, arrayed in the skin of a tiger,

was led before him, and Gesar mounted upon his back.

Brugmo brought food for Gesar, in case he grew hungry on the way, and across the neck of his horse she laid garlands of sugar and raisins. She exhorted them, crying, "Heavenly brown horse! If you lack the heart or strength to bring my lord to the end of his journeying, I will shear off your mane and tail, and burn your body to ashes. Gesar, my noble lord, if you lag behind your horse in cunning or prowess, your thumbs will be slit like a coward's and thrown into the fire, and I will never more look upon your face."

Gesar answered, "Your words are eagles' wings to uplift my spirit." Taking leave of Brugmo, he set forth upon his journey.

But again and again as he rode, he turned his head to look back at Brugmo where she stood in the shadow of her yurt, until at last his horse rebuked him. "Why do you twist your head like a calf in search of his mother? Your road lies onward, not back. If your heart is in this task, let your eyes follow. If not, return as you came."

Gesar said, "You do well to upbraid me, my brown one," and he fixed his eyes before him, and traveled onward toward the realm of the twelve-headed giant.

CHAPTER FIVE

THE GIANT
WITH TWELVE HEADS

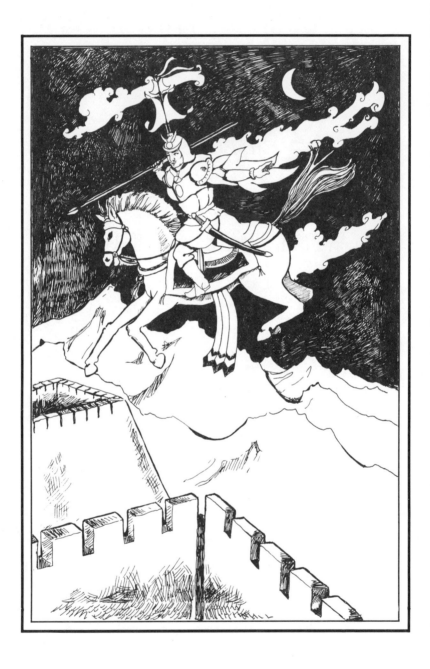

THE GIANT
WITH TWELVE HEADS

*A*s Gesar journeyed toward the realm of the twelve-headed giant, he came to the foot of a high mountain. Leaving his horse to graze in the valley below, he climbed the mountain to its peak. Standing upon the summit, he cried, "My three sisters! I go to do battle with the giant who has stolen Aralgo away. Hearten me with your counsel! Inform me with your wisdom! It is I, your brother, who calls upon you!"

Gesar's three sisters appeared to him at once in the guise of a cuckoo and said, "Beloved brother! Your task is not a simple one, yet guided by our wisdom, it may be that you will gain victory over your enemy. Now hear our counsel. Soon you will enter a forest where there roams a bull so huge that he devours the grass of three pastures at a gulp and drains the waters of three rivers from source to mouth. You must kill this bull before you can enter the realm of the twelve-headed giant. Go warily, lest he overpower you, yet

boldly, lest he mock you for a coward. From Sumeru our love will shelter you." So saying, the cuckoo spread her wings and soared aloft.

Gesar descended the mountain and continued his journey. But darkness descended upon the land, until he could see neither to the right nor the left, nor above him nor in front, neither the palm of his hand nor the ears of his horse. So he dismounted and rolled his cloak into a pillow for his head. Turning his face toward the eastern sky, he lay down upon the ground to rest.

As Gesar slept, the Wild Bull of the Forest stole softly up to his horse, and thrusting forth his tongue, stripped him at once of his mane and tail. Thrusting forth his tongue a second time, he stripped Gesar's silver arrows of their plumage.

"You churlish bull!" said the horse. "Gesar will know of this affront to him!"

The bull tauntingly replied, "Tomorrow I will swallow you and Gesar, just as now I have swallowed your mane and tail."

Awaking at dawn, Gesar saw that his horse had been stripped of his mane and tail, and stood abashed before him. He saw that his arrows, like the arrows of a baby, were bare of plumage. He cried out to his sisters, "You dwellers in the sky, is this the shelter and care you pledged me? As you slept on Mount Sumeru,

the Wild Bull of the Forest thrust forth his tongue, stripping my horse of his mane and tail and my thirty silver arrows of their plumage!"

At once Gesar's three sisters appeared to him in the guise of a cuckoo. "Are you a woman, brother," they said, "that you make such a clamor to the earth and the sky? If you choose to weep, abandon this enterprise and return to the shelter of your yurt. But if you would journey farther and reach your goal, do not waste your strength in childish lamentation. The bank that resists the onslaught of the waves will be the staunchest boulder, and he who does not falter in the face of disaster will have valor of the finest flint, for no one can destroy it.

"Take our words to heart, dear brother, and weep no more. We will restore the plumage of your arrows, and you shall judge whether their luster is dimmed or brightened. As for your horse, let him feed three times before midday on the wheat that covers the nearby field, and his mane and tail shall flourish again in splendor on his body."

The sisters then restored the plumage of Gesar's arrows. Gesar looked on them where they lay in his quiver and saw that their luster was brighter than before. Three times before midday he led his horse to the field of wheat and told him to eat of it. When the horse had eaten three times, his mane and tail flourished again in splendor on his body. Gesar then

mounted his horse and said, "Follow the footprints of the bull as he roams through the forest and overtake him or else I will slash the four hoofs from your legs, strip you of saddle and bridle, and journey homeward on foot."

The horse answered, "Doubt me not, master. I will do my part, but look to your own labor. You must send your arrow through the mark upon the Wild Bull's brow. Should it swerve by so much as the breadth of a hair, I will fling you from my back and return to your glorious sisters on Sumeru."

"Well-spoken!" cried Gesar, and struck his steed with so sharp a blow that the horse soared aloft and galloped through the air. Gesar sought to restrain him. "Have you become a falcon or a hawk that you are suddenly minded to fly?" he said. "I pray you, go softly upon the surface of the earth, dear companion, as you are accustomed, and if in my haste I struck you too sharp a blow, I humbly ask your pardon."

The horse descended to the earth and followed the wild bull's footprints. Soon they came upon the bull where he had felled with the tip of his horn three oaks that barred his way to a pleasant stream.

The horse cried out, "Ho there, Wild Bull! Gesar has come, whose steed you despoiled of his mane and tail, and his arrows you robbed of their plumage."

The Wild Bull answered, "I welcome him, for now I will devour arrows and steed and Gesar himself."

So saying, he leaped upon them, but Gesar's arrow found him in midair, pierced the snowy ring that marked his brow, and laid him low. The earth shuddered and the forest groaned beneath his fall.

Gesar, rejoicing, plunged his sword into the Wild Bull's throat, and carved out a tender morsel, so that he might partake of the flesh of his enemy. But when he would have thrust it into his mouth, his sisters appeared to him in their proper guise, and said, "Stay, Gesar! As a hero you have attacked your foe and as a master slain him! But as a glutton now you fall upon him to gorge yourself with his flesh. Eat your fill, good brother, but not until you have offered sacrifice to all the gods in turn, and to your sisters who have watched over you from Sumeru."

Gesar repented of his folly and said, "In truth, I do not know why I fell so rashly upon him, whether to sate my hunger or my rage. Forgive me my sin, heavenly ones, and take at my hands this offering I make you of the unsullied flesh of the Wild Bull."

He built a fire and scattered incense upon it, and offered up a sacrifice to the gods of the Wild Bull's flesh. When they had accepted the sacrifice, he and his horse feasted on what remained.

"Now you must proceed alone, beloved Gesar," his sisters said, "for the way is foul with all kinds of abominations, and we may not go further. You will come soon to an enchanted river, where headless men

and trunkless horses float here and there. They will shriek and moan and make a great noise, trying to frighten you. Pay no attention to them, but strike the water three times with your magic sword and cross in safety to the other shore. Continue onward, and before long you will see before you two walls of rock, standing so close to one another that a shadow cannot pass between them. How you shall overcome this barrier and many more besides that the giant will prepare for you, you must ask of your dauntless heart and your nimble wit!" And the sisters vanished.

Gesar journeyed onward until he came to the enchanted river, where headless men and trunkless horses floated here and there. They shrieked and moaned and made a horrible noise, attempting to frighten him, but he paid no attention. Striking the waters three times with his magic sword, he crossed in safety to the other shore.

Gesar rode onward until he saw before him two walls of rock, standing so close to one another that a shadow could not pass between them. He said aloud, "In Tibet I have seen two walls of rock separate from one another, revealing a passageway for a horse and rider. Yet when a horse and rider have arrived within their shadow, they have come together, crushing the travelers in their cruel embrace. But these rocks that guard the realm of the twelve-headed giant are witless rocks, ignorant of their power."

The rocks heard Gesar's words and said to one another, "Shall we let the rocks of Tibet outdo us in guile? Let us move apart, and when this horseman rides within our shadow, we will come together and destroy him. Never again will he extol the power of other rocks above our power."

The rocks then quickly moved apart, disclosing a passage for horse and rider. Gesar sped so swiftly through the gap that before they could come together to destroy him, he had emerged in safety on the other side. Angered that he had escaped them, the rocks crashed so fiercely upon one another that they shattered and fell in many fragments to the earth.

Gesar journeyed onward, and came at length upon a herdsman who tended camels. "Herdsman, where is the castle of the giant?" he said.

"Upon the summit of the highest mountain," replied the herdsman.

"Is the way I must follow rugged or smooth? What monsters lie in my path?"

"The way is rugged, and the ridges are guarded by sentinels—the pearly ridge by the sons of the shining gods, the golden ridge by the sons of men, the ebony ridge by the sons of the giant. You must answer to all three before they will allow you to seek the giant's castle."

Gesar gave thanks to the herdsman and traveled onward until he came to the pearly ridge guarded by the sons of the shining gods. When the sons of the gods saw him, they called out, "Alas, red-footed mortal! Our master will kill us if he learns of your presence here! Swiftly depart from this place!"

"And if I will not?"

"Then you are no mortal, but one mightier than he. Can it be indeed that you are Gesar, lord of the ten great regions of the earth, whose coming has been foretold to us? How may we know you?"

"I am Gesar indeed, lord of the ten great regions of the earth, whose coming has been foretold to you. Do not be afraid of me, but draw near, children of the gods, and tell me why you serve the giant, since his ways are evil ways!"

"Unmindful of our parents' bidding, we left the heavens to play for an hour in the fields of men. But before we had landed on earth, the giant seized us and carried us here, to guard this pearly ridge against his enemies."

"Then how will you reward me if I kill this giant and free you from his power?"

"If you go to slay him, we will give you counsel to guide you, and treasures to ease your toil. The golden ridge above us is guarded by the children of men. They too are unwilling sentinels, and when you have re-

vealed yourself to them, they will speed you on your way. But the ebony ridge is guarded by the children of the giants, who are your enemy. How you will overcome them we do not know, but when this task is done, enter the forest that will loom before you, and travel through it, paying no attention to anything you will see or hear. You will come out at the foot of a lofty peak. The giant's castle lies on the summit of this peak, but it is shrouded in mists so dense that day and night are one, and neither man nor beast may find the path. Take then this golden and this silver net, and when the mists engulf you, cast them into the skies, and they will snare the sun and moon to light your way through the darkness."

Gesar then took the nets, and traveled to the golden ridge that was guarded by the sons of men. They rejoiced that he had come to deliver them from bondage, and sped him on his way.

Now he came to the ebony ridge that was guarded by the sons of the giants. Dismounting, he made an offering to the gods and sought their aid. "You blessed ones whose power is unending! Unloose your dragon's thunder! Let lightning shafts fly! In the midst of the uproar send a shower of hailstones as huge as my doubled fist to crush the heads of these sentinels. For your Gesar would ascend the perilous peak to do battle with his enemy!"

The gods heeded his prayers. They let fly their lightning shafts and yoked their dragons to the

chariots, their voices thundering to one another across the skies. When the giants heard the uproar, they were dismayed and flung themselves on the ground, but a shower of hailstones as huge as Gesar's doubled fist descended upon them and crushed their heads. So Gesar passed by them.

Traveling further, he entered a dark forest where demons in the guise of beautiful maidens beckoned to him and sweet voices called, but he paid no attention to anything he saw or heard. He came out of the forest at the foot of a lofty peak shrouded in mists so dense that day and night were one, and he could not see where to guide his horse. Casting his nets into the sky, he snared the sun in the golden net, and the moon in the silver net. By their light he ascended the perilous peak and reached its summit.

Gesar saw the walls of the giant's castle before him, but he could not find a gate. He said to his magical horse, "Carry me up into the air as you did in the wilderness and then, plunging downward like a golden arrow, set me within the walls of the giant's castle. Beware, for if you fail me in this, I will slash your hoofs from your legs and travel home on foot. But if I fail and fall from your back and die, may my unworthy flesh be eaten by hounds!"

"Alas, dear master, when have I begrudged you my magic power, that you should barter thus with if and if! Withdraw to a distance of thirty paces from the

castle walls and, urging me forward with your voice and your hand, cry, 'On! On, flower of Kormuzda's herd!' and you shall see how bravely I will serve you."

Gesar withdrew to a distance of thirty paces from the castle walls, and seizing the reins in his left hand and pressing his legs hard against the flanks of his wondrous steed, he struck him three times with his right hand and cried, "On! On, flower of Kormuzda's herd!" The horse galloped to the castle walls and soared aloft. Then, plunging downward like a golden arrow, he set Gesar down within the courtyard.

"You have served me bravely, my faithful one," Gesar said, "and now you shall take your ease. Return to Sumeru, and bed yourself in Kormuzda's heavenly stalls. Feed on heavenly fodder and quench your thirst in the waters of heavenly streams. When I have need of you again, I will summon you."

The wondrous horse gave thanks to his master, and lifted up his voice and cried, "Keeper of Kormuzda's blessed steeds! Let down a ladder so that I may ascend to you!"

"Who would ascend?"

"I, the brown wonder-steed!"

The Keeper of Kormuzda's steeds let down a ladder made of rope, binding one end to Sumeru's silver peak, while the other end swung free above the earth.

But the brown steed roared in anger at the sight of the rope ladder, his nostrils belching black smoke and his eyes spitting flame. "How can this ladder carry my weight?" he cried. "Am I a foal or Gesar's brown wonder-steed? Before I came halfway, it would break and send me crashing down to earth. Draw it back, careless Keeper, and let down another ladder of strong chains!"

The Keeper of the steeds drew back the rope ladder and let down a ladder of strong chains, whereon the brown wonder-steed ascended to Sumeru.

When his horse had gone, Gesar approached the castle that rose before him, its silver roof crowned by a chimney of rubies. "Where are the lord and lady of this silver castle?" he cried out.

Aralgo heard his voice from within and flung open the gate. Weeping, she threw herself into his arms. "Like the golden sun you rise upon my darkness, O heaven-born!" she cried.

Gesar chided her, saying, "Are you not a woman of little wit, weeping when you should laugh? Dry your tears and tell me why you left the Valley of Pleasant Winds to journey here. For if the giant took you by force, I will kill him, but if you went freely, I must slay you, so that your sin against me may be atoned."

Aralgo told him all that had happened and Gesar said, "You have been ill-used, and Trotun shall answer

to me for his deed. But now I will seek out the giant and challenge him, and may the victory be his whom the gods love."

"Yet what if he should slay you, my Gesar? In all your exploits you have never encountered a monster as fearful as this one. You had better flee for your life before he returns from the chase to find you here."

"Do you give this counsel to some untried stripling, or to the chosen son of the gods? Enough talking! Tell me where I may go in search of him."

"If you are resolved to challenge him," Aralgo said, "stay a little until I have beguiled him of his secrets. When the sun is red, he will return from the chase, riding his copper-green mule, and carrying a horned moose upon his back. When he has eaten and drunk to his heart's content, I will question him, and from a hidden place you will hear his words."

Gesar and Aralgo then entered the castle and came to a marble chamber where a jewel burned in the floor. Aralgo touched the jewel and it vanished, revealing a deep pit. When Gesar crept into the pit, the jewel appeared again, and all was as before.

When the sun was red, the giant returned, riding his copper-green mule, and carrying a horned moose upon his back. He roared, "Let my small pike be brought, that I may dislodge the crumbs of my morning meal!"

His small pike was brought, and from the crevices of his teeth he dislodged the bones of forty men and let them fall to earth. Then, entering his marble chamber, he sat down to a feast of roasted elephants and lions.

When he had eaten and drunk to his content, he summoned the Lady of Ten Thousand Joys to keep him company. She sat at his feet and placed her white hand in his. Gazing upon him, she said, "My matchless husband, dearer than all the world to my heart, I am oppressed with fear that one day the odious Gesar will come and challenge you to combat."

"Do not fear, my tender one, for with my weakest finger I will crush him and fling him back again into Tibet."

"No, he is not so lightly crushed nor flung into Tibet. Tell me, I pray you, how you will defend yourself against him, so that I may be relieved of this sorrow."

"I will tell you nothing, for he that has learned wisdom counts no bush a tree, no hawk a bird, and no woman as his friend."

"What empty talk is this! Now I remember how when I came here your beautiful wives all vanished down your gullet, so that I might reign supreme. Do you think now to condemn me to their horrible fate, having found another fairer than Aralgo? Woe, woe is

me! Would that the noble Gesar would come and slay me, wretch that I am!" And Aralgo cast herself upon the ground, uttering grievous cries and lamentations.

"Stop crying," said the giant, "and draw near to me again, for I have not found anyone fairer than you."

But Aralgo would not, and at length he said, "I will reveal all my mysteries to you if you will only raise your head from the ground and smile upon me."

Aralgo raised her head from the ground and smiled upon him, and the giant said, "Gesar may not slay me until he has slain my younger sister, who inhabits the topmost branches of the Tree of Delight in the kingdom to the east. Nor may he slay me until he has slain my elder sister, who is a mighty yaksha, and dwells in the kingdom to the west. But first he must gain possession of the beetle that she has hidden away and destroy it, for the beetle is your husband's soul that his sister jealously guards.

"If Gesar should succeed in all these undertakings, still he must put to death the golden fish that slips from my right nostril as I sleep and plays on my right shoulder, and the silver fish that slips from my left nostril as I sleep and plays on my left shoulder. These deeds being done, he will not overthrow me until he has severed my twelve heads from my shoulders. Judge then, my Lady of Ten Thousand Joys, if I am not well defended against this Gesar."

"You are a creature whose like neither walks upon the earth nor soars through the blue heavens nor peoples the sea. And that you are my husband and I am your wife, I count as a great blessing."

The giant rejoiced in Aralgo's words of praise, and lay down to sleep. When the day broke, he arose once again, and mounting his copper-green mule, went forth to the chase.

Aralgo touched the jewel that burned in the floor and it vanished, but when Gesar had emerged out of the pit, the jewel appeared again and all was as it had been. Gesar strode forth from the castle, and in the court he called out, "Brown wonder-steed! Gesar has need of you!"

From the heavens the ladder of strong chains was let down and the brown steed descended. His companions flung ashes after him, crying, "Farewell, brown wonder-steed!" as was their custom when one departed from their midst. The ashes were transformed into clouds that sailed in the sky.

The brown horse carried Gesar over the castle walls and into the kingdom on the east, where he found the Tree of Delight in whose topmost branches lived the giant's younger sister.

Gesar stood at the foot of the tree and said aloud, "Surely this is a daughter of the gods, or of the dragon-princes, or it may be of Gesar himself, for in all my

journeying I have not beheld a maid so wondrously fair. If only she would come down from the branches to speak with me! Yet can it be that my eyes have played me false, and this creature is no maid indeed, but a magpie or a crow? For why would a beautiful maiden spend her days in the branches of a tree?"

The maiden thought, "Truly this youth speaks with the wisdom of age. Am I a bird that I should inhabit the branches of a tree? I will go down to him."

She descended and stood at Gesar's side, and said to him, "Who are you and where do you come from?"

"I come from the Everlasting Realm, whose black-capped lama gave me before I left a necklace of many strands to be my talisman. Shall I give it to you?"

"Why not? I would like to wear the talisman of the black-capped lama."

"Will you wear it around your ankles or around your tender throat?"

"Why around my ankles? No, I will wear it around my throat as necklaces should be worn."

"Allow me then, in exchange for my talisman, to place it there." Gesar took three bowstrings, and laid them around the throat of the giant's sister and drew them tight, until the breath left her body and she fell at the foot of the tree. The skin of her tender throat was transformed to scales and her body to the body of

101

a reptile. Kindling a blaze that consumed both reptile and tree, Gesar turned back again to the giant's castle.

When the sun was red, the giant, mounted on his copper-green mule, returned from the chase. He said to Aralgo, "Alas! Four of my heads throb with terrible pain as if they had been split in two by bludgeons."

Aralgo answered, "Could it be that you did not capture anything for your midday meal, and your pangs are the pangs of hunger?"

"No, for I captured three herds of yak, together with their herdsman, and feasted abundantly."

"Then do not forth tomorrow, I pray you, but stay at home so I may take care of you."

"Am I a baby that I should stay at home for an aching head?" And on the next day the giant bound up four of his heads in snowy kerchiefs and went forth to the chase.

When he had gone, Gesar summoned his wonder-steed from Sumeru and traveled to the kingdom on the west. There a yellow doe leaped before him. Taking aim, he shot an arrow from his bow, and the arrow pierced the doe's brow and thrust its head forth from her shining flank.

The doe was transformed into a yaksha whose upper lip ascended to the skies, while her lower lip hung down and touched the earth. She seized the

arrow's plumage at her brow, trying to draw the arrow from the wound, but she could not; she seized the arrow's head at her side, seeking to dislodge it, but in vain.

"Who are you, youth?" she cried.

"Do you not know me, yaksha?" he answered.

"No, for until this hour, may it be accursed, I have never before laid eyes upon you."

"Am I not the giant and your younger brother?"

"The giant and my brother! If this is true, you have grown exceedingly fair. When did you put off your usual guise and assume the body of a handsome youth?"

"When I took Aralgo as my wife."

"Why did you wound me even now with an arrow from your bow?"

"Out of the hatred that I bear you, for since my birth you have jealously guarded the beetle that is my soul, not allowing me even a glimpse of it."

"Because I knew your rashness and feared that you would imperil your soul, I have kept it from you."

"Let me look upon it now, and when I have looked my fill, I will draw the arrow out of your wound."

103

The yaksha hurled the beetle at Gesar's feet and he stepped upon it. Then seizing the arrow's plumage at her brow, he drew the arrow from the wound, but plunged it again into her evil heart. She fell lifeless before him. Kindling a blaze that consumed both yaksha and beetle, Gesar turned back again to the giant's castle.

When the sun was red the giant, mounted on his copper-green mule, returned from the chase. He said to Aralgo, "Eight of my heads throb in bitter anguish as if they had been split in two by swords." Flinging himself upon the marble floor, he writhed in pain, but after a while he went to sleep.

A golden fish slipped out of his right nostril as he slept and played on his right shoulder; and from his left nostril a silver fish slipped out and played on his left shoulder. Gesar came forth from his hiding place, a bludgeon in either hand, and lifting the bludgeons high above his head, he brought them down on the giant's shoulders, killing the gold and silver fish and rousing his enemy from sleep.

When the giant saw him, he bellowed in rage and sprang upon him as a tiger springs from the crest of a mountain upon a goat. But Gesar drew his lightning-sword from its sheath; before the giant could wreak his anger upon him, he severed eleven heads from the monster's shoulders. He raised his sword to strike the last, but the giant stopped him, crying, "Radiant one

who has shorn me of my honor and my heads, hold your avenging hand! For I never injured you, except that I took your wife to be my wife when you had abandoned her. Now I acknowledge you as my master: with all my guile I will serve you, and with all my magic lore I will uphold your power. Together we will do battle against your foes and destroy them utterly. In summer we will dwell in my domain, for summer cools her ardor on this peak; but in the winter we will journey to Tibet, for winter visits you gently."

The giant's words were pleasant in Gesar's ears, and he stayed his hand. Clear as a silver trumpet the voice of his sisters sounded from Sumeru, "His words are as false as his black heart! Slay him while you can, for the flesh of his body is turning to bronze, and soon you will strike in vain!"

Straightway Gesar struck the giant's neck, but his neck was transformed to bronze, and the edge of the lightning-sword could not enter in. He tried to thrust its point through the giant's breast, but the giant's breast was transformed to bronze, and the point of the lightning-sword would not enter in. Swiftly he plunged his sword through the giant's paunch, and sought and pierced his heart, and when he drew his weapon out again, he saw how molten bronze dripped from its blade.

He severed the twelfth head from the giant's shoulders and kindled a blaze that consumed the giant

where he lay. Aralgo cried out, "Lion-souled one! Staunch as the four cliffs of Sumeru! You have destroyed the giant and all his kin! Drink now this cooling drink, for it is a balm against your weariness!"

She then gave to Gesar a black drink in a golden chalice, the drink of forgetfulness. He took it and drank of it deeply, and when he had drunk, all that had happened to him since his birth fled from his memory.

CHAPTER SIX

THE THREE
SHIRAIGOL KINGS

THE THREE
SHIRAIGOL KINGS

\mathcal{I}t happened that on the very day when the son of heaven and scourge of evil on earth, the all-conquering Gesar, had taken the drink of forget-fulness from the hands of Aralgo, the three Shiraigol kings met in council to advise with one another about where to find a fair and worthy bride for Prince Gereltu, son of King Tsagan, chief of the three kings of Shiraigol.

King Sheera, the second brother, said, "Let us send messengers to the great ones of the earth, and let the messengers bring us tidings of the beauty and seemliness of their daughters."

King Chara, the youngest brother, said, "Let our couriers be the birds of the air and the beasts of the wilderness that travel more swiftly over the earth than men on horseback."

King Tsagan listened to his brothers' words, and he sent a hawk to the kingdom of Balpo, to learn if the daughter of Balpo's king was fair. He sent a fox to the realm of Enedkek, to learn if the daughter of Enedkek's king was fair. To the land of Tibet he sent a raven, to learn if the daughter of Gesar was fair.

After a year the hawk returned from Balpo and bowed before his masters. "The daughter of Balpo's king is as fair as a newborn doe at her mother's side," he said. "Yet she is unversed in the ways of men and courts, and therefore unworthy to be the bride of our prince."

After two years the fox returned from Enedkek and bowed before his masters and said, "The daughter of Enedkek's king is as fair as a quiet lake among sunny hills. Yet she is reluctant to leave her father's house, and therefore she may not be Gereltu's bride."

After three years the raven returned from Tibet and bowed before his masters, and they saw that the light of his eyes was quenched in darkness.

"What enemy has darkened your sight, O raven?" Tsagan asked. "What news do you bring of the daughter of Gesar?"

"I bring no tidings of the daughter of King Gesar, for when I beheld Brugmo, his chosen wife, I quenched the light of my eyes so that they might not gaze upon glory less than hers. When she stands up-

right, she is like a mountain pine decked in gleaming silks. When she sits, she is like the yurt of a prince in a green valley. By sunlight she melts to a flame, by moonlight she freezes to crystal. When she raises her head, it is as though she led ten thousand warriors to battle, so measureless is her splendor."

King Tsagan said to his brothers, "If the raven speaks truly, here is a princess worthy to be the bride of Gereltu. If he speaks falsely, he is the very king of liars. Are your words true or false, O golden tongue?"

"True, gracious king! What is more, if you have a mind to seize Brugmo, delay no more. Gesar lingers still in the country of the twelve-headed giant, and while he is away from home, it may be that you will thrive in your venture. But if he should return again, he will surely kill you."

The three kings took counsel with one another, and resolved that they would journey to Tibet to see Brugmo with their own eyes. They transformed themselves into a vulture so huge that his outspread wings darkened the light of the sun. The vulture's snowy head was King Tsagan, his yellow body was King Sheera, and his ebony tail was King Chara.

The vulture flew to Tibet and alighted at dawn on Brugmo's yurt, causing its walls to tremble and its golden columns to sway from side to side. Brugmo sprang up from her couch and summoned the Tiger-

hero, whom Gesar had named defender of his household when he rode away to do battle with the giant.

Brugmo cried, "Brave Tiger-hero! Some monster has alighted on my yurt! Whether he is the giant who, having slain the son of heaven, comes now to seize his wife I do not know. Stretch your bowstring taut and lay your arrows ready to hand, and we will go forth together and destroy him."

The Tiger-hero stretched his bowstring taut and lay his arrows ready to hand, and went out of the yurt with Brugmo at his side. But when he saw the vulture, whose outspread wings darkened the light of the sun, his heart grew faint, and he let his weapons fall to the ground.

Brugmo cried out in scorn: "You Tiger-hero whose valor forsakes you before the gaze of a bird, give me your bow and arrows, and I will do what your woman's heart denies you strength to do!"

The Tiger-hero answered, "You do well to censure me, Lady Brugmo, yet I will not yield my bow and arrows to you, lest my shame be doubled in the eyes of my honored lord who gave you to my care."

"Then steel your hand to the task that lies before you and pierce the vulture's breast!"

The Tiger-hero placed his arrow against the bowstring, aiming it at the vulture's breast. But his hand trembled; the arrow swerved, striking the out-

spread wing of the vulture, whose yellow feathers rained about their heads. The bird soared aloft and, circling three times above Brugmo, disappeared from sight.

The vulture returned to his kingdom and as he landed on the earth, his snowy head was transformed into King Tsagan, his ebony tail was transformed into King Chara, and his yellow body was transformed into King Sheera, with a wound in his right arm.

Tsagan said to his brothers, "What need for more words? We have seen that the raven spoke truly of Brugmo's beauty. Let us assemble our armies and march upon the hosts of Tibet, seize Brugmo, and bring her here to be the bride of Gereltu, my son."

King Sheera answered, "Think this through, good brother! For it is said that mighty Gesar is a god indeed, disguised as a mortal, and that his thirty heroes are such warriors as we may not hope to overcome."

King Chara, the youngest brother, said, "To capture the chosen wife of Kormuzda's son is a deed for the gods to frown upon. Let us abandon this undertaking, and choose a bride for Gereltu from the daughters of neighboring princes."

"There is no one among them to equal Brugmo!"

"If there is no one to equal Brugmo, let us choose the fairest among them, and dress her in robes as rich and jewels as bright, and name her Brugmo. Then who

113

will be bold enough to stand up and say, 'You are not Brugmo'?"

"Brothers," replied Tsagan, "I do not like your counsel. If you wish, you may stay at home like men whose eyes have been blinded or whose ears have been deafened or whose bodies have been stricken by some terrible disease. But as for your warriors, they will ride with me to Tibet!"

King Chara answered, "Your words are such words as are flung at cowards, O King, but we are accounted heroes and your peers! Since you are resolved, let wine be brought to us, and we will pledge ourselves to this venture!"

A golden bowl was brought, filled with strong wine. The kings of Shiraigol drank from it and pledged to march into Tibet, seize Brugmo, and give her to Gereltu for his bride. On the next morning they led forth their hosts, numbering three million three hundred thousand.

In Tibet Brugmo commanded that the yellow plumage shot from the vulture's wing be placed on thirty asses, and bearing a single feather in her hand, she rode at their head to the yurt of Shikar, which lay a day and a night from Gesar's yurt.

At dawn she came to the Stream of the Elephant, where Shikar watered his horses. When he saw her, he said, "Why do you come with the dawn, fair

Brugmo? Is it a golden tree you carry in your hand or a yellow feather?"

"Why would I carry a tree in my hand, Shikar? It is a yellow feather, shot from the plumage of a mighty vulture that perched upon my tent. He was so huge that though the Tiger-hero only grazed his wing, these thirty asses can scarcely carry the weight of the plumage he dislodged."

"Was the head white?"

"White as the snow that crowns our highest mountain peak."

"Was the body yellow?"

"Yellow as the feathers with which these beasts are laden."

"Was the tail black?"

"Black as the magic coal without rift or seam."

"I know this vulture. In magic guise the Shiraigol kings have looked on your beauty, whereof the raven that fluttered above you for many days gave them tidings. Would that I had slain him, as I thought to do, before weightier matters drove him from my mind. Yet there is nothing to fear, for though Gesar is absent, what can these three kings do against Shikar, the comrade of his heart, and the thirty heroes and the three hundred chieftains of the tribes! Be of good

cheer, fair Brugmo, and stay here until I have assembled our princes in council together."

Shikar assembled the princes, and recounted to them all that had befallen Brugmo. Trotun stepped forward. "The Shiraigol kings, who have always been our friends, are now our foes because of Brugmo. Therefore let Brugmo flee to some lonely isle in the Chatun Stream, and when the kings learn that she is gone from our midst, they will leave us unmolested."

Shikar answered, "Trotun, you have the soul of a flea! In peaceful times you look wisely upon the world, but you speak folly when danger is at hand. Return to the shelter of your home, for we have no need of you. But for you, our thirty heroes and three hundred chieftains of the tribes, assemble your warriors! Let the battle hosts of Tangut and Tibet gather together, on horseback and on foot, and meet at the mouth of the Satsargana Stream!"

The couriers rode forth, carrying Shikar's word throughout the land, and the battle forces of Tangut and Tibet gathered together and met at the mouth of the Satsargana Stream. They were arrayed according to their rank, on horse and foot, with their standards borne before them, and their chieftains at their head. The thirty heroes on their fiery horses, dressed in the shining panoply of war, ranged themselves side by side, awaiting Shikar.

He came on his winged charger and drew rein before them. "Are the hosts assembled?" he asked.

Shumar the Eagle-hero answered, "They are assembled."

"Shumar the Eagle," said Shikar, "ride on my left! Nantsong, youngest of Gesar's heroes, ride on my right! Let the trumpets sound nine blasts to herald our coming, and we will go forth to do battle for our beloved king and against his enemies!"

The trumpet sounded nine blasts, and Shikar, with Nantsong on his right and Shumar the Eagle on his left, and his shining warriors at his back, advanced to meet the foe. But when he came to the peak of the Mountain of Sand, he saw in the northern sky a monstrous cloud that came nearer and nearer, and at length he saw that the cloud was no simple cloud but a mighty horde of the wild animals of the forest. Some were whole, and some were badly wounded. Commanding his armies to halt, Shikar cried to a buzzard that trailed his torn wing behind him, "Where are you from and who is it who has hurt you like this?"

The buzzard answered, "The Shiraigol hosts that camp on the Chatun Stream have driven us before them as they marched, and harried us with all kinds of missiles, killing many of my companions and wounding more." So saying, the buzzard continued on his way.

Shumar the Eagle bent his keen gaze upon the Chatun Stream where the enemy was camped. "We may not overcome them," he cried aloud, "for their

numbers are as great as the stars of the sky fallen to earth."

Nantsong answered, "Shame on you, Shumar! When have you seen the stars fall to the earth, that you should speak such madness! So what if their power is greater than you can measure? Is ours so small?"

"Though you are the youngest of Gesar's heroes, Nantsong," said Shikar, "your words are sweet with wisdom. If our enemy seethes like a caldron of boiling milk, let us be like the ladle that empties it. Let us be a flood to their flame, a channel to their torrent, and to their arrogance a chastening rod. We will divide our troops into three parts. I will lead my troops against King Tsagan, and bring back the head of each enemy slain. You, Shumar, will attack King Sheera, and take the right thumb from the hand of each enemy slain. Nantsong will go forth against King Chara, and take the right ear from the head of each enemy slain. When we have put to rout those that remain, we will return again to the Mountain of Sand."

They divided their forces into three parts, and placing themselves at the head of their warriors, they rallied their mounts. "Rush like a torrent down the mountainside! Leap like a wolf into the midst of the foe!" Their horses whinnied three times in answer, and waved their tails three times from side to side, and struck their forefeet three times upon the earth. They

rushed like torrents down the mountainside, and leaped like wolves into the midst of the foe, and all the hosts of Tibet followed after them.

Earth and heaven seemed to spin around in terror, so furious was their assault. It was as though their swords were made of flame, and their arrows shot from the bows of angry gods. Their chargers snorted columns of smoke so dense comrade was hidden from comrade. They struck the enemies' standards into the dust and unhorsed their riders and trampled on those on foot.

Shikar slew five hundred thousand men of the armies of King Tsagan, and his warriors slew as many. Driving before them the horses they had taken captive, they withdrew to the Mountain of Sand.

Shumar the Eagle slew a hundred thousand men of the armies of King Sheera, and his warriors slew as many. Driving before them the steeds they had taken captive, they set forth for the Mountain of Sand.

But before they had traveled the distance of an arrow's flight, they heard a cry. Turning his head, Shumar saw that a horseman, riding a stallion to whose feet anvils were bound, sought to overtake him. He wheeled his charger, awaiting the horseman's coming.

When he was within six paces of Shumar, the horseman drew rein and cried, "Shumar who is called

119

the Eagle! I am Mergen of the Six Thumbs, who shoots six arrows at once from his bow! Though you have slain a hundred thousand men and routed many more besides, me you have neither slain nor put to rout. I charge you, beggar and thief of Tibet, give back the horses you have stolen, or I will shoot six arrows into your body and take your head back in triumph to King Sheera!"

"Did I capture your horses that I might return them again, you six-thumbed fool? Begone while you are still whole, and do not vaunt your prowess, for you are no archer, but a babe that toys with arrows."

"Will you make trial of your excellence, O magpie's tongue?"

"That I will. See how three eagles soar over yonder mountain. Mark now my arrow's flight!"

Shumar spanned his bow, and his arrow sped to the foot of the mountain and vanished within, but issuing forth again at the mountain's crest, it soared even higher, and plunged itself into the breast of each eagle in turn, and brought them to earth. But the arrow returned to Shumar.

Mergen said, "I will not challenge you, for you have wrought such wonders as I have never beheld before. Yet the peacock takes pride in her tail, and the wise man in his honor, and I dare not return to my master with empty hands. I pray you, give me two

chargers of all you have taken, a black and a white, and I will depart from your presence and bless your name."

"Whether you bless or curse my name, I care not, Knight of the Six Thumbs. But I wish to know why your stallion has an anvil bound to each foot."

"So untamed is his spirit that but for these anvils he would spurn the earth and fly with the winged creatures of the air."

"He pleases me. Deliver him up to me, and I will give you in payment two chargers, black and white, and seven more besides."

"No, I will not deliver him up to you. For how shall I meet my comrades, without my horse?"

"What hinders me from slaying you and taking your horse, you cowardly idiot? You would have perished long since, except that I would have you carry to the three Shiraigol kings the tale of your encounter with Shumar. But if you dispute my will, you will feel my power!" And he lifted his spear to strike.

But before the spear descended, Mergen said, "You are as swift to anger as the bird of heaven whose name you bear! Take the stallion and give me in payment a black steed and a white, and seven more besides."

So it was done. Shumar took the stallion to whose feet anvils were bound and withdrew to the Mountain of Sand.

Nantsong the Falcon, youngest of Gesar's heroes, slew fifty thousand men of the armies of King Chara, and his warriors slew as many. Driving before them the horses they had taken captive, they set forth for the Mountain of Sand.

But Nantsong thought of the shining pigtails that adorned the heads of the slain, and how bravely they might bedeck his dappled steed. He said to his chieftains, "Go before me to the Mountain of Sand, and I will come after you." He returned to the battle-field and severed from the heads of the fallen their shining pigtails, tieing them to the mane and tail of his horse.

Teergen, son of the king of Enedkek, discovered Nantsong as he severed the pigtails. "What knave are you who thus dishonors our dead?"

"No knave, but the youngest of Gesar's heroes and your sworn foe."

"Do you think to frighten me with the name of Gesar, you puny stripling? I am Teergen, son of the mighty king of Enedkek, whose glory dims the light of the sun and moon. I command you to return to me the pigtails you have taken."

"I would yield to your command, except that to please you is to grieve my horse. See how bravely these pigtails bedeck his beauty."

122

"Because I honor your valor, Nantsong, I will parley with you. See where three wild geese wing their way over the heavens. If I kill them all with one arrow, the pigtails are mine. If I fail, you shall take them with you to Tibet."

"Let it be so!"

Teergen spanned his bow, and aimed his arrow at the wild geese that winged their way through the heavens. But when Nantsong lifted his eyes to follow the flight of the arrow, Teergen shot it against his foe. It entered one armpit and came out from the other, and Nantsong fell to the ground.

But immediately he rose up again, loosening his girdle and binding it under his armpits to staunch the black blood's flow. "You were not born to kill me, heart of a sheep," he said, "but to take death at my hands. My arrow will pierce you, leaving you just enough life to carry you back to your friends. When you have told them how, like a viper, you wounded Nantsong, and he, defying death, dealt destruction to you, then perish, Teergen, son of the king of Enedkek, whose glory shall be forgotten in your shame."

As he said, so he did. His arrow pierced the skull of his enemy, who faltered and fell. But just enough life was left in him to carry him back to the Shiraigol camp, where, having related the manner of his downfall, he died.

123

Nantsong set forth again for the Mountain of Sand, but his limbs were heavy, and his throat was parched with thirst, and his wounds tore at his arms like the fangs of an adder. He swayed and would have fallen to the right, but his dappled steed turned his long neck to the right and held him erect in the saddle. They rode onward, and he swayed and would have fallen to the left, but his dappled steed turned his long neck to the left and held him upright in the saddle. They rode onward, and now he swayed forward, and though the dappled steed tried to stretch back his neck and hold his master up, he could not. Then Nantsong fell from the saddle and lay bereft of power on the ground.

Two wolves drew near to feast on the flesh, and two ravens to pluck out his eyes, but the dappled steed stood guard above him and struck at them with his forefeet, snorting black smoke and flame from his nostrils. When they tried to steal on him from behind, he struck at them with his hind feet, so that sparks flew from beneath his hoofs, searing their flesh.

He cried out in sorrow, "Nantsong! Falcon of heaven! Are you snared indeed? Where are my companions who used to surround me like feathers surround a bird? Where are your brothers who were closer to one another than the leaves of a tree? I cannot leave you to seek them, for the wolves would devour you and the ravens pluck out your eyes. Who then would lay his hand in tenderness upon me and call me his faithful dappled steed?"

124

As he lamented, he looked at the ravens that hovered above him, and suddenly a thought came to him. "Birds of ill omen," he said, "it will do you no good to hover above me, for before I will let you pluck out my master's eyes, I will pluck out yours. But if you will be my friends and serve my wishes, you shall feast upon the bodies of these wolves in reward for your service."

The ravens answered, "How may we serve you, steed of the artful tongue?"

"Fly swiftly to the peak of the Mountain of Sand, and tell Shikar that Gesar's Falcon-hero perishes of thirst and a bitter wound in his side."

The ravens flew swiftly to the peak of the Mountain of Sand, and circling above the head of Shikar, they cried, "Pay heed to our words, lord of the hosts of Tibet! A dappled steed with an artful tongue and a valorous spirit bids us say that Gesar's Falcon-hero perishes of thirst and a bitter wound in his side."

A great cry rose up from the warriors. Drawing their swords from their sheaths, they shouted, "Vengeance! Vengeance on he who wounded Nantsong the Falcon!"

But Shikar lifted up his hand and quieted the clamor. "If the Falcon is wounded, my friends, be sure that he who dealt the wound is slain. Nantsong has more need of healing than of vengeance. Summon Kinggen the Healer so he may go with me in search of

our brother. When Nantsong's wound has healed, we will return again."

Shikar took Kinggen the Healer behind him on his saddle, and the winged charger followed the flight of the ravens until they came to the spot where Nantsong the Falcon lay, bereft of power. His dappled steed stood guard over him, tears flowing from his eyes.

But when he saw Shikar, he checked his weeping and fell upon the wolves that had harried him and tore them limb from limb. And the ravens feasted upon their flesh.

Kinggen the Healer poured the juices of fragrant herbs into Nantsong's wounds and made him whole. Rising refreshed, Nantsong mounted his dappled steed, and so they journeyed back to the Mountain of Sand.

When his comrades saw Nantsong, they laughed for joy, and when they saw his horse, adorned with the shining pigtails of the enemy, their laughter echoed to the camp of the three Shiraigol kings who trembled to hear it.

Suddenly Shumar the Eagle cried, "Two riders gallop toward us. One is the Lady Brugmo, and the other is Trotun, who follows her."

The riders drew near. Having scaled the Mountain of Sand and reached its summit, Brugmo said, "I have come to join you, for it ill becomes the chosen wife of

Gesar to stay at home, awaiting the battle's outcome. But why Trotun has followed me I do not know, for he came by his own will and not by mine."

"I feared for Brugmo's safety, and therefore I followed her," said Trotun.

But Shikar answered him: "For whose safety did you fear, Trotun, when you counseled her to flee to some lonely island in the Chatun Stream, so that the Shiraigol kings might leave you unmolested? No, you have come to share our spoils, having shunned our perils. But though we have captured a mighty horde of horses, there are none for you.

"Nine chosen herds must be offered up in thanksgiving to the gods, and nine must be paid in tribute to Brugmo, and when the thirty heroes have taken their share, and all our warriors have been rewarded, and a steed bestowed on those who now go on foot, what will be left for you, dauntless Trotun, except to return on the nag that bore you here?" Trotun was angered by Shikar's words, but the warriors laughed.

When nine chosen herds had been offered up in thanksgiving to the gods, and nine had been paid in tribute to Brugmo, those that remained were allotted among the thirty heroes and the chieftains and warriors of the three tribes of Tibet, and a steed was bestowed on those who went on foot. Shumar the Eagle gave to Shikar the tireless stallion he had taken from Mergen of the Six Thumbs, to be a companion to

the winged charger. But no horse of all the treasure was given to Trotun.

Night fell upon the peak of the Mountain of Sand, and the armies slept.

CHAPTER SEVEN

TROTUN'S TREACHERY

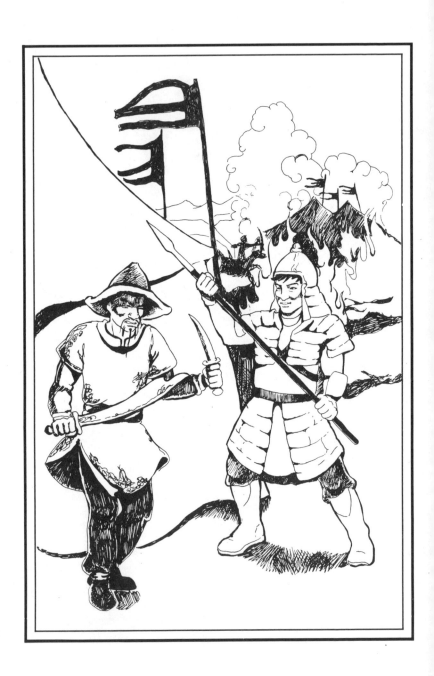

TROTUN'S TREACHERY

*T*rotun did not sleep, for his anger writhed like a serpent in his breast. "Not even one horse from all their treasure have they allotted to me," he thought. "I will go down the mountain and, under the cover of night, I will plunder the enemy's herds. When I return, I will flaunt my booty before Shikar, who has made mockery of me. But I will give none of my spoils to him or to his comrades."

So that evening Trotun stole down the slope of the Mountain of Sand to the enemy's camp, and, screened by the darkness, he plundered their herds. Driving his booty before him, he set forth again for the tents of his countrymen.

But one named Ulan of the Red Eyes saw him as he journeyed over the plain, and rode in pursuit. Trotun, hearing the galloping hoofbeats behind him, leaped from his steed in fright and sought shelter in a woodrat's narrow lair. Ulan of the Red Eyes drew rein

131

before the lair and shouted, "Come forth, wondrous woodrat who plunders the herds of men!"

Trotun answered, "The herds are yours, Shiraigol knight! Take them and my steed as well, but leave me within the shelter of this lair, for I am an old man and cannot serve you."

"Since you are so lavish of your bounty with herd and steed, I would have your sword as well and your bow and arrows. Come forth now or I will kindle such a blaze before your lair as will drive you forth, whether living or dead—I don't care which!"

Trotun crept forth, and Ulan of the Red Eyes bound him hand and foot, and flinging him over his saddle, returned with him to the Shiraigol camp. At dawn he led Trotun before his masters, and told how he had captured him.

Trotun lay prone before the Shiraigol kings and cried piteously, "Grant me my life, most glorious among the sovereigns of the earth, and I will tell you how you may win victory over your enemy and take Brugmo captive."

King Tsagan ordered that Trotun be released from his bonds. When he was released, Trotun bowed nine times to the ground, striking his palms nine times upon one another. Then laying his forehead on the feet of King Tsagan, he awaited his word.

"Rise, Trotun," said King Tsagan, "and say what you have to say!"

Trotun arose. "Though Gesar's heroes are mighty beyond all men, and not to be equaled in the arts of war, you may overcome them through guile. Return my armor to me, my weapons, and my horse, and give me twenty more horses that have passed their prime. I will go to my countrymen and say: 'The Shiraigol kings have withdrawn from the Chatun Stream and travel homeward. I followed in their wake, but so swift was their retreat that I could not overtake them. Coming upon these horses that they had abandoned, I drove them here.' Hearing these tidings, Shikar will disband his armies and return to his home on the Stream of the Elephant, but Brugmo will prepare a feast for the thirty heroes in honor of their victory. Having drunk deeply, they will sleep soundly, and in that hour you may safely send your forces to take Brugmo captive."

King Tsagan rejoiced in Trotun's counsel and commanded that his armor, his weapons, and his steed be returned to him, and that he be given some twenty horses that had passed their prime. Driving this meager herd before him, Trotun set forth again for the Mountain of Sand.

When he had reached the peak, Shikar and the thirty heroes greeted him. "Welcome, Trotun! What sorry lot of horses is this that keeps you company?"

Trotun answered, "The Shiraigol kings have with-drawn from the Chatun Stream. Humbled in defeat, they travel homeward. I followed them, hoping to take captive a herd of horses, since you would give me nothing of all your treasure. Yet their retreat was so swift that I could not overtake them. Coming upon these abandoned horses, I drove them here, lest you doubt the truth of my tidings."

"Are you our enemy that we should doubt your tidings? Comrades, Trotun our kinsman brings us word that the Shiraigol kings have withdrawn from the Chatun Stream and travel homeward. Therefore let us disband our hosts and return to our dwelling places!"

But Brugmo said, "Shikar, I pray you, take heed! How often has Gesar warned us: 'Trotun's voice is as soft as the rarest silk, and his words are as sweet as the finest cake, but his heart is harder than the hardest flint.' Do not trust him, Shikar, for he is a liar whose like the golden sun has never seen!"

"He is a liar and a coward, Brugmo, yet when has he betrayed us that we should charge him with so foul a deed? He speaks truly! Let us disband our hosts, and return in peace to our dwelling places."

Thus the hosts were disbanded. Shikar returned to the Stream of the Elephant, but the thirty heroes, riding to Brugmo's right and to her left, brought her in triumph to her yurt.

134

She ordered a feast to be prepared in honor of their victory, and they ate abundantly of the flesh of oxen and boars, and drank deeply of strong brandy. At dawn they slept.

But Brugmo said to Arigon, her servant, "Ride forth, Arigon, and tell me if the Shiraigol kings have indeed departed, for my soul is beset with fears."

Arigon rode forth, but before he had crossed two streams he saw the Shiraigol hosts advancing toward him. He would have turned to sound the alarm, but an enemy's arrow pierced his breast, and he fell from his horse and died.

The hostile forces crept silently up to the sleeping heroes of Tibet, their swords unsheathed. Brugmo, awaiting Arigon's tidings, saw them from the doorway of her yurt and uttered a piercing cry.

The heroes awoke, but their eyes were heavy with sleep and their limbs with drinking, and the strength of thirty was less than the strength of one. They tried to summon their horses, grazing in a distant pasture, but though each horse answered the summons with a loud whinny, they could not break the ranks of the enemy that kept them from their masters.

135

The heroes fought on foot. Their swords flashed, and their arrows sped to the mark, and their spears were plunged into the breasts of the enemy. Each hero slew fifty thousand men of the Shiraigol hosts. But King Chara leaned from his saddle and thrust his spear through the breast of the Tiger-hero, and the Tiger-hero fell to the ground and died.

King Sheera urged his steed against Nantsong, who was engaged in combat with a thousand men, and the steed rode him down and trampled upon him. When he would have risen, King Sheera plunged his sword into Nantsong's throat and slew him.

King Tsagan sent his arrow against Shumar, who seized it to turn it from his breast. But the point, which was poisoned, pierced his hand, and he swayed and fell. King Tsagan smote his head from his shoulders, and he perished.

All the heroes of Gesar perished except Bodotshi, who was named the Fire-hero, for upon him the gods had bestowed the power to transform himself into flame. Now like a burning coal he rolled through the enemy's lines, and those whom his breath touched were consumed to ashes. The earth over which he passed became a lake of fire, and those who stood upon it were engulfed in flames. While no one could approach Bodotshi to slay him or quench his heat, so fiercely did he rage to destroy the enemy that at length he was consumed in his own fires.

Brugmo saw with a sorrowing heart the slaughter of Gesar's heroes. When she saw that no one remained to defend her, she withdrew into her yurt, and fastened under her robe a saber forged of unbending steel. Around her shoulders she girded a bow and quiver, with a hundred golden arrows on which Gesar had cast a potent spell before he set forth for the country of the twelve-headed giant.

"Because the son of heaven lingers in distant realms, and Shikar, unheedful of my warning, has departed to the Stream of the Elephant, and the thirty heroes have yielded up their lives in my service, shall I sit idly by and weep, awaiting the coming of the foe? No! I will go forth and do battle with him!"

She went forth at once. Forty chieftains advanced to meet her, checking their steeds to a soft and sober pace, lest the dust stirred by their hoofs should sully the countenance of Lady Brugmo.

"Valiant ones who have come to take me captive, are you chieftains in your land or simple tribesmen?" Brugmo asked.

"We are chieftains in our land," they answered.

"It is well. Arrange yourselves in a single rank in front of me, and I will go to your head, and so deliver myself up to the kings of Shiraigol."

They arranged themselves in a single rank before her, and she placed herself at their head. But before

they could read her purpose, she sped a golden arrow from her bow that pierced the breast of each chieftain in turn, tumbling them from their horses and stretching them lifeless upon the ground.

Mounting the foremost horse, she galloped into the midst of the enemy. Her arrows fell like a golden rain among them, and so potent was Gesar's spell that each arrow slew a thousand warriors before it sank earthward like a wounded bird and was still. Those that escaped the arrows were hurled into confusion, for comrade grappled with comrade, and frenzied horses trampled their riders to death beneath their hoofs. Terror reigned among the Shiraigol hosts seeking to flee Brugmo's fury.

But King Tsagan lifted up his voice above the din of battle and cried, "Are you men or geese that you flee from the wrath of a woman? Stand fast and surround her! By my father's head I swear that whoever defies my command will die at the point of my sword!"

The Shiraigol kings rode up and down among the frightened armies, restoring their ranks to order. They surrounded Brugmo, whose quiver was empty of all but a single arrow, saved for her direst need.

From beneath her robe she drew forth the saber of unbending steel and laid about her, slashing to right and left, unhorsing a thousand riders at each blow. But now they pressed upon her from every hand, and

Brugmo could neither escape through their lines nor wield her weapon.

She transformed herself into a wasp and rose above them, but King Tsagan transformed himself into a white hawk, and King Sheera into a yellow hawk, and King Chara into a black hawk, and they pursued her and drove her back to earth. All her arts being spent, she yielded to them.

Thus was Brugmo taken captive by the three kings of Shiraigol.

They mounted her upon a blue-black horse that bore her proudly, and set forth for their domain. Brugmo plucked a hair from her eyebrow and laid it in the palm of her hand. "Go with the wind to the Stream of the Elephant," she said softly to it, "and carry the news of my plight to Shikar!"

The hair went with the wind to the Stream of the Elephant and entered Shikar's nostril, making him sneeze. "What is your message, hair of Brugmo?" he asked.

The hair replied, "Trotun has betrayed you, and the Shiraigol kings have slain the thirty heroes and taken Brugmo captive."

Shikar leaped to his winged horse and rode to Sanglun's yurt on the Lion's Stream. "I go to take vengeance upon the Shiraigol kings," he cried, "for

they have slain Gesar's thirty heroes and taken Brugmo captive!"

"Whose power has brought this evil?" asked Sanglun.

"The power of Trotun's treachery!" answered Shikar.

Sanglun said, "My son, the past lies far behind me, but the future lies near at hand. I will gird on my armor and go into battle at your side."

"No, sire, for you are like an oak blasted by many storms, whose boughs are withered and whose sap flows sluggishly in its veins. Stay here and await the coming of Gesar, lest there be no one to welcome his return."

"My bones are withered indeed, and my blood flows sluggishly, and the storms of many years have blasted my frame. I would have chosen the joy of death in battle, but since you have said, 'Your strength is spent, Sanglun! Wait here for the coming of Gesar!' I answer, 'My strength is spent, Shikar, and as you have decreed it, I will await here the coming of Gesar!'"

Shikar bade his father farewell, and gave rein to his winged charger. "Take me to the peak of the Mountain of Sand, from whose height I will look down on the retreating forces, and see their numbers!"

The winged horse leapt forward and soon brought his master to the Mountain of Sand. Shikar looked down from the height upon the retreating forces, and saw that they numbered four hundred thousand warriors. In their midst he saw Brugmo, mounted on a blue-black steed.

His heart was oppressed and he cried out, "How shall I answer my brother when he returns and says, 'What have you done, Shikar?' Shall I answer him, 'Because I did not heed your word and the word of Brugmo, your thirty heroes are slain and your chosen wife a captive in the land of the Shiraigol kings!' No, I would rather plunge down among them, to kill and be killed, for what is my life worth to me without Gesar's love?"

Brugmo heard his words and cried to him, "Shikar! Hawk among men! Though the tree is shattered, do not the roots remain? Though the man perishes, does not his seed live after him? Do not despair, but seek out Gesar. Alone you will not prevail over this enemy, but Gesar will restore the thirty heroes to life and together you will take vengeance on those who have wronged him!"

Shikar answered, "Will you veil your countenance from your captor's gaze until I have returned with your husband, Gesar?"

"For twelve months I will veil my countenance from my captor's gaze," she replied. "When that time

is past, I must wed Prince Gereltu. Make haste, therefore, Shikar! Make haste, winged charger! Leap like a wild goat over the mountain peaks, swim through the waters like the king of fish, outspeed the rushing winds that sweep the heavens, and bring me succor!"

Shikar would have turned his steed to do her bidding, but King Tsagan taunted him. "Valiant Shikar! Faithful friend to your master! What will you say to Gesar when you have found him? Will you say, 'The thirty heroes have died in defense of Brugmo, but I abandoned her to her captors and went in search of you, for I feared to challenge them to battle single-handed, lest they should harm me!'"

Shikar's rage was inflamed by his enemy's taunt, and his eyes rolled in his head. Drawing forth his saber from its sheath, he whetted the keen edge upon a flint, then struck his winged charger a mighty blow and leaped from the mountain peak to the plain below.

He mowed down the Shiraigol forces like a reaper mows down a field of grain; he dealt with them like an axe deals with the forest. The Chatun Stream was choked with bodies, and her waters ran red with blood.

Having slaughtered seventy thousand men, Shikar sought out their leader. "Where are you hiding, Tsagan? Your tongue is loud but your deeds are timid! Come forth, and measure your strength against

142

Shikar's so that all your warriors may know what kind of man their leader is!"

King Tsagan came forth to meet Shikar, but when his horse and the winged charger saw one another, they whinnied in joy, for they were close kin and in their youth had frisked together in the same pasture. Now they would not contend against one another. When their riders urged them on, they retreated, and though the lash flayed their shoulders and the spurs their flanks, the horses defied the bidding of their masters and went back instead of forward.

Shikar thought, "I will dismount and drink at the Chatun Stream, for I am weary from my labors. Once my strength is restored, I will bend this horse to my will."

He dismounted to drink at the Chatun Stream, but its waters were defiled with his enemy's blood, and scarcely had his lips touched the water when he fell into a deep swoon on the bank.

King Tsagan, seeking a means whereby he might conquer his enemy, dismounted and hewed down a mighty pine that crashed across Shikar's throat and almost strangled him. But the winged charger, fondling him with his tongue, awoke him. Shikar tried to rise up but he could not, nor could he move his head to the left or to the right. King Tsagan bore down upon him with a drawn sword.

143

A hawk swooped down from the heavens and hovered above Shikar. As the sword descended, striking his head from his shoulders, the life of Shikar departed from his body and entered the body of the hawk. Soaring aloft, the hawk disappeared into the blue heavens.

CHAPTER EIGHT

DEFEAT OF THE SHIRAIGOL KINGS

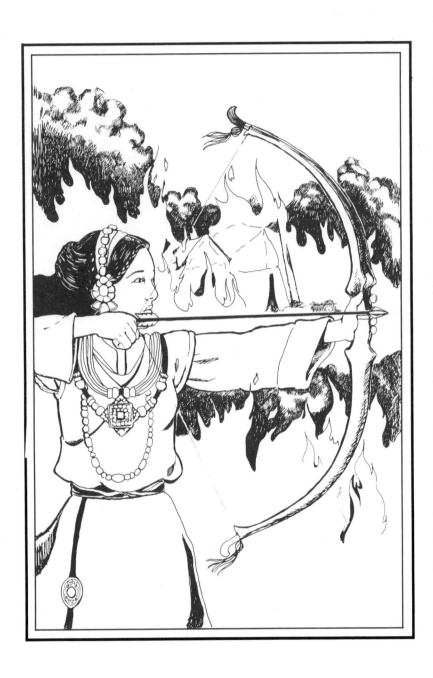

DEFEAT OF THE
SHIRAIGOL KINGS

*A*s Brugmo traveled in the midst of her captors, she took from her quiver the golden arrow saved for her direst need. She plucked a feather from its plumage and pricked her wrist with its point, then wrote in her blood on the arrow's shaft a message to Gesar. She said to the arrow, "Golden arrow blessed by Gesar's hand, find your master!" Hurling the arrow from her, she continued on her way to the realm of the Shiraigol kings.

Now Gesar was taking his ease upon the wall of the giant's castle, with Aralgo by his side. She was afraid to leave him, lest someone should come and tell him of her deception. When he walked outside, she kept him company; when he stayed inside, she was always close by.

But the magical brown horse lay imprisoned in a deep dungeon where she had enticed him with oats and golden wheat to follow her. She had shackled his legs with iron chains, weighted his neck with an iron

halter, bound him fast to an iron beam, and sealed the dungeon gate. For many months he lay without food or drink. Every twelve months, when the snow had melted and the streams flowed, she entered his dungeon and scattered a handful of hay for him to eat, and gave him a cup of water to quench his thirst, then left him to languish for another twelve months.

Now as she sat with Gesar on the castle wall, he said, "The midday sun beats fiercely on my head. Go inside and prepare a cooling drink to refresh me."

Scarcely had she departed than an old woman appeared on the path below him, driving an aged cow in front of her.

Gesar said, "Good mother, why do you drive this old cow to pasture? Surely she has served you well and earned rest from her labors, for her horns are crumbling with age."

The old woman answered, "She has served me nine weary years, for she was a calf when Gesar vanquished the twelve-headed giant. Yet she is doomed to labor until the charm that holds him here is lifted." The old woman went on her way, but Gesar's heart was troubled.

Now a rook flew from the east, lighting on the path below him. "Is your land barren of food, hungry rook," Gesar asked, "that you come here to forage?"

The rook answered, "The land of my birth lies to the east of this castle, near the Black Pyramid. I have always flown west to look for food for my mate and fledglings. When night comes, I return to them to guard them from harm. But you have dealt far otherwise with those who love you best, all-conquering one overcome by Aralgo's wiles! Where is Brugmo, your beautiful wife? Where is Shikar, your heart's brother? Where are the thirty heroes and all your people who have looked to you for comfort? Since you have abandoned them to death and captivity, it would be well to withhold your scorn from those who obey the Buddha's law."

The rook went his way, but Gesar's spirit was in turmoil, as when an angry wind sweeps through the branches of a tree, shattering its peace.

Now the enchanted arrow appeared in the blue sky, winging its way to Gesar. Marking him where he sat upon the castle wall, the arrow descended and came to rest within his empty quiver. Gesar drew it forth and read upon its shaft Brugmo's words.

"Are you alive, Gesar? Then know that your brother Shikar has vanished from the earth and your thirty heroes lie slain on the battlefield through Trotun's treachery. Brugmo, your chosen wife, has been taken captive by the three Shiraigol kings. If you live, deliver me from their bondage. If you have been overthrown by the giant's might or the craft of Aralgo,

I will bare my countenance to the gaze of my captors and wed Prince Gereltu."

Upon reading these words, the darkness of nine weary years dropped away. Gesar cried out, "How I have wronged you, Shikar my brother, and my thirty heroes, and Brugmo, my peerless wife!" So bitterly did he weep that the sound of his grief reached even the ears of his brown horse.

The sound of Gesar's weeping multiplied the horse's rage a hundredfold. As his rage increased, so did his power, until his strength was like the strength of thirteen dragons. He tore himself from the iron beam that held him, flung the iron halter from his shoulders, broke the iron chains on his legs, and crashed through the dungeon gate.

With a mighty roar he approached his master. "Your noble brother has vanished, your thirty heroes are slain, and your chosen wife is captured–all to bring content to Aralgo! Now that your wits have been restored to you, can you do nothing but howl to the high heavens like a beaten slave?" So saying, he turned his back to the castle, and ran away.

"Return to me, wondrous steed!" Gesar cried. "The gods have endowed you with wisdom, but I am a fool!"

But the horse would not come to his summons. "My sisters," Gesar cried, "capture my steed and lead

him back to me, for without him I may not escape from this land of woe!"

The voice of his sisters sounded from Sumeru. "He will not return, for you have offended him. But mount whatever horse you find in the giant's stables, and follow him, and it may be that you will win him back from his anger."

In the giant's stables, Gesar found the copper-green mule. Leading him forth, he said to Aralgo: "Artful one who has brought dishonor upon me! Give me my helmet and my armor and spear, that I may leave this land of woe!"

Thrusting her head out of the window, Aralgo cried, "What helmet and what armor and what spear, you beggar out of Tibet on a stunted steed! Cursed be that sorrowful day when you slew my gentle husband, the twelve-headed giant, who would have protected me from your ill usage!"

Gesar said nothing, but opening his jaws wide, he sent forth a cry that rocked the earth. Eighty-eight times the giant's castle spun round and round, then burst into a raging flame.

Aralgo flung his helmet and his armor and spear out of the window. Gesar cried to the flames, "Let her issue forth unscathed!" She came forth, but the castle was consumed to ashes.

When Gesar had put on his armor, he mounted the copper-green mule, and seating Aralgo behind him, he went down from the high peak. The bones of the giants who had guarded the ebony ridge lay moldering in the dust, but the sons of men who had watched the golden ridge, and the sons of the gods who had kept the pearly ridge had long ago left the realm of the giant.

When Gesar had journeyed for a night and a day and an hour, he came upon a herd of wild horses, and in their midst crouched the brown horse, trying to hide from his sight.

"Ho, marvelous brown horse!" cried Gesar. "Will you come to my call, or shall I shoot your four legs from your hooves and leave you to die?"

"When I lived with you in Tibet, Brugmo adorned me with trappings of silk. She fashioned the buckles of my harness of gold, and laid a velvet cushion under my saddle to protect my coat. In winter she decked me with sable skins, and in summer she led me into shady groves to drink. At dawn and noon and nightfall she fed me with oats and golden wheat, and often when you feasted she brought me almonds and sugar from your table, and other delicious foods.

But I was parted from her, and from Shikar and the thirty heroes, and from my comrades whom I loved well. Aralgo cast me into a dungeon and bound me

152

with iron chains, leaving me to languish, hungry and thirsty, for nine weary years. Therefore my anger was kindled against you, dear master, for my wrongs were greater than I could bear."

"Your anger is just," Gesar answered, "and your wrongs shall be avenged!" Mounting the horse, he turned his head toward the Shiraigol realm that lay to the north. Aralgo followed after him on the copper-green mule.

Soon she cried out, "I am hungry!" Gesar flung her a leather stirrup and answered, "For one who is hungry, here is delicious food!"

"This is no food, but a stirrup of foul leather!"

"Go ahead and eat—it's the flesh of a wondrous ox!"

Aralgo took the stirrup into her mouth, but spat it out again. "It tastes as bad as it looks!" she said wrathfully.

They rode farther, and presently she said, "I am thirsty!" Gesar pointed out the bed of a stream whose waters the sun had drunk, and answered, "For one who thirsts, here are cooling waters!"

"I see no waters, but a bed of mud!"

"Drink, for they are the waters of an enchanted stream!"

Aralgo took the mire into her mouth but spat it out again, saying angrily, "Why do you give me leather stirrups to eat and mire to quench my thirst?"

"So that the wrongs of my brown horse may be avenged, and your evil deeds requited. For the drink of forgetfulness by which you enslaved the son of heaven, you shall come no more to the Valley of Pleasant Winds but wander through the Lonely Desert until your years are over!"

Immediately Aralgo was transported to the Lonely Desert, where she wandered until her years were over, but Gesar continued on his way to the realm of the Shiraigol kings.

As he rode through the wilderness, a voice rang out, "Stay, Gesar!"

"Who calls my name?" Gesar asked. "Neither man nor bird nor dog lives in this wilderness, yet surely one cried out, 'Stay, Gesar!'"

But no answer came. He would have ridden further, but when he spurred his horse forward again, the voice rang out again, "Stay, Gesar!"

Gesar looked around him and in front of him and behind him. At length he looked up at the sky and saw a creature whose head was that of a man, but whose body and tail were like a hawk's. The creature flew toward the earth and landed on his saddle-bow.

"All-conquering, all-healing Gesar! I am Shikar, your beloved brother. Since my head was smitten from my body at the Chatun Stream, I have awaited your coming."

Gesar gave a mighty cry and embraced his brother, and they wept so that the earth shook with their weeping, and the mountains and the forest wept to see their grief.

When their tears were spent, Gesar scattered incense upon the earth, quieting its tumult. "Let us be done with sorrow," he said. "I will make sacrifice to Kormuzda my father, and entreat him to restore you again to mortal form."

"Do not entreat him, Gesar," Shikar answered. "Whether I would be restored to mortal form again I do not know. But until you have made an end of the one who vanquished me through the felling of a pine—and all his kin—my spirit will not find rest in heaven or on earth."

"Then farewell, Shikar," Gesar said. "I go to win repose for your spirit." Taking leave of his brother, he galloped onward.

When he was within three days' journey of the Shiraigol borders, he drew from his quiver the enchanted arrow which Brugmo had sent him. "Go before me," he said to the arrow, "and destroy the sentinels that guard the borders, lest they announce

my coming to my enemy!" Leaping from his hand, the arrow took its flight to Shiraigol.

There were three sentinels who guarded the borders of the kingdom. The first could see farther than a falcon can fly in three days, the second could hear farther than a fox can run in three days, and the third could reach farther than an army can march in three days.

The Far-Seeing One said, "What creature is this that flies toward us? Is it an eagle? Can it be a raven? It moves swiftly toward us, but its shape is hidden from my sight."

The Far-Hearing One answered, "It is neither an eagle nor a raven moving swiftly toward us, but an arrow singing as it flies!"

The Far-Reaching One said, "Do not fear, friends, but do as I say, and all will be well. Let the Far-Hearing One take shelter behind me, his arms clasped around my waist. As I shield him, even so let him shield the Far-Seeing One. Thus we will wait for the arrow to come. Before it can do us harm, I will pluck it out of the sky and break it in two."

They did as the Far-Reaching One commanded. When he saw the arrow, he plucked it out of the sky and tried to break it in two, but he could not. The arrow lifted him up, together with his comrades who clung behind him, then plunged with them into a

rushing river and left them there to drown. When Gesar came to the borders of Shiraigol, his arrow awaited him there on the river's bank, its head thrust through the mire, its golden plumage shining brightly in the sun.

Gesar returned the arrow to his quiver and traveled farther, until he came within sight of the castle of the three Shiraigol kings. There he stopped in the shade of a pleasant grove, where a spring gushed forth. Transforming himself into an aged lama and his horse into a beggar's oaken staff, he lay down beside the spring as if asleep.

In the cool of the day the daughters of the three Shiraigol kings, tossing a red fruit from hand to hand, made their way there to play in the shade and drink the spring's clear water. Brugmo followed after them, her face veiled from sight.

As the daughters tossed the red fruit, it fell from their hands into the lama's mouth where he lay by the spring. They ran to his side and berated him. "Who are you, old graybeard, who has dared to enter the grove of the three kings' daughters, and snatch our red fruit into your mouth?"

"Alas, my children," the lama answered, "I am a holy man in search of peace. Be charitable and do not take the fruit, but let me eat it. If it should please you to bow your heads before me, I will bless you in the Buddha's name."

157

But the maidens mocked him. "Shall the daughters of a king bow down before an unclean beggar?" they cried.

Now Brugmo drew near and questioned the lama. "Where have you come from, old man, and where are you going?"

"I journey from foe to friend by way of this land," he answered. "I would rest a little, for my limbs are weary, and because I am hungry, I would eat this red fruit."

Brugmo knew him for Gesar by his words. "For shame, maidens!" she cried. "Would you take from the lips of a holy man the fruit the gods have laid there? Go, quench your thirst at the spring, then leave and trouble him no more!"

The maidens did as she bid them, and when they were gone, Brugmo said, "You are no aged lama, but Gesar, son of Kormuzda and my well-loved lord."

Gesar answered, "Unveil your face, that I may know you truly for Brugmo."

Brugmo unveiled her face, and it was as though the sun and the moon and the stars lighted the grove.

Gesar embraced her, saying, "The enchanted arrow that has faithfully served us will take you now to the bank of the Chatun Stream. When I have taken

vengeance upon your captors, I will look for you there."

The enchanted arrow leaped from its quiver and spread its plumage, making a pleasant couch for Brugmo. Seated upon it, she was swiftly borne to the bank of the Chatun Stream.

Gesar then released from beneath him a golden spider as big as a calf in its second year. The spider scaled the wall of the castle and encircled it, saying, "Let him who slew the Tiger-hero tremble, for the day of his downfall is at hand!"

Again the spider encircled the castle wall, crying, "Let him who slew Nantsong the Falcon tremble, for the day of his downfall is at hand!"

For a third time he encircled the wall of the castle, crying, "Let him who slew Shumar the Eagle tremble, for the day of his downfall is at hand!" Having encircled the wall of the castle three times, the spider vanished.

King Tsagan was seated upon his throne, with his second brother at his right hand, and his youngest brother at his left. Hearing the cry of the spider, he summoned his sentinels before him, and questioned them. "Who was the man who encircled the wall of the castle three times, uttering a strange cry?"

The sentinels answered, "No man, nor a wild beast of the forest, nor a gentle beast of the fields, but a

horned creature with a human voice whose like we have never seen."

The three kings of Shiraigol trembled, for they knew that Gesar had come from the land of the twelve-headed giant to take vengeance upon them.

But King Tsagan said, "Let ten thousand of our best warriors assemble in the castle court, and let them go forth to do battle with this insolent one who dares send his messenger of evil to the Shiraigol kings."

At once ten thousand warriors assembled in the castle court, but before they could go forth in search of the enemy, a sword of lightning pierced the rampart, killing a thousand men. Those who remained were thrown into confusion, trying to retreat here and to press forward there. But again the sword of lightning pierced the wall, killing a second thousand. Ten times the sword flashed in their midst, and before it vanished the bodies of ten thousand men lay lifeless in the castle court.

Mounted on his wondrous steed, Gesar leaped to the wall. A rainbow encircled his head, and his jeweled armor burned like a living flame. From his horse's nostrils black clouds of smoke and yellow tongues of fire ascended to the skies. Brandishing his lightning-sword, he cried, "Wherein did I wrong you, kings of Shiraigol, that you invaded my realm, slew my heroes, scattered my people over the earth, and took my chosen wife captive?"

160

The voice of King Tsagan cried from within the castle: "We will restore your chosen wife to you!"

"And what of my heroes, whose bones lie bleaching on the field where you struck them down? Will you restore my heroes as well?"

"How can we give life to the lifeless?"

"Then, if you are warriors, come forth and do battle with me! For if you will not, I will seek you out in your hiding place and slay you."

"We will do battle with you, Gesar, and as we vanquished your heroes, so shall you be vanquished!"

"Let the gods judge!"

King Tsagan rode out on his tireless horse and Gesar leaped down from the rampart to confront him. "Ride from the east," Gesar said, "and I will come from the west, and in this place let our naked swords clash upon one another, sealing our fate."

One rode from the east and one from the west, and in the place that Gesar had appointed their naked blades clashed upon one another. But Gesar's lightning sword split the sword of his enemy in two and pierced his breast. As King Tsagan fell to the earth, his spirit left his body and was seized by demons.

Now King Sheera came forth from the castle, his bow girded about his shoulders, and his quiver hanging by his side.

"Will you slay me with an arrow, King Sheera?" Gesar asked.

He answered, "I will."

"Then shoot as a skillful marksman, and as a hero I will abide your shot!"

King Sheera took aim, but Gesar raised his arm and the arrow passed under it, lodging in the wall behind him.

Then Gesar fitted an arrow to his bow, and let it fly. The arrow pierced King Sheera's forehead; he fell to the earth, and his spirit left his body.

Now the youngest of the Shiraigol kings came forth from the castle. He bore neither sword nor spear; no bow was girded about his shoulders, and no quiver hung by his side.

"Do you come to slay or be slain, youngest of the Shiraigol kings?" asked Gesar.

"Neither to slay nor be slain, Gesar, but to meet my fate. For shall I seek to escape you who have overthrown my older brothers in combat? But since I count a warrior's death sweeter than the flight of a coward, I have come to measure the strength of my arm against you."

"Alas, to win peace for the soul of my brother I must slay you, brave youth! Otherwise I would spare

162

you for your valiant heart. Come, try your strength against me!"

Gesar dismounted from his horse and King Chara grappled with him, trying to force him to the ground, or fling him over his head, or crush his bones. But Gesar stood as steadfast as a column driven many feet into the ground. His bones were like the tusks of an elephant, and the strength of his enemy could not overcome him.

Having tried in vain to overthrow him, King Chara cried out, "Now try your strength against me!" Gesar clasped him and raised him high above his head and dashed him to the ground with such might that all his bones were shattered and blood flowed from twenty wounds. His spirit left his body and departed to another realm.

Having taken vengeance upon the Shiraigol kings, Gesar withdrew from their land and galloped to the bank of the Chatun Stream where Brugmo waited for him. She mounted behind him on the brown steed and together they journeyed to Tibet.

CHAPTER NINE

GESAR'S RETURN

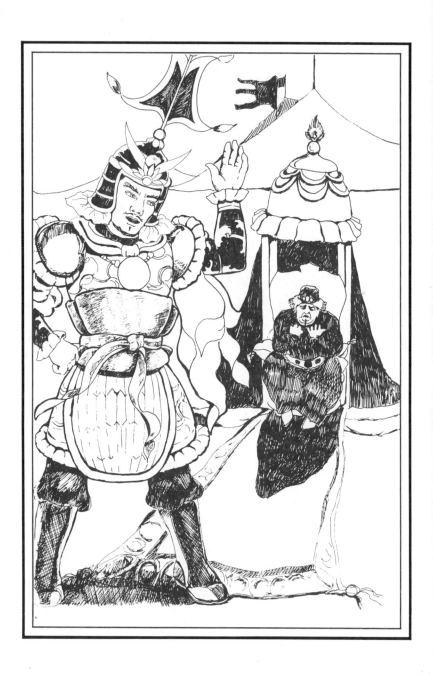

GESAR'S RETURN

The brown steed swiftly carried Gesar and Brugmo into Tibet. When they were within its borders, Gesar transformed himself into a merchant, the horse into a lowly ass, and Brugmo into a servingman who led Gesar's beast by the reins.

Arriving at the family lands, they met a herdsman among his flocks. "Who rules over this fair land, and where does he live?" asked Gesar.

The herdsman answered, "The vile Trotun inhabits mighty Gesar's yurt and sits on his throne. Peace has made way for strife, and gladness for weeping, and his people curse the day when Gesar forsook them to do battle with the twelve-headed giant."

They traveled further, until they came within sight of Gesar's yurt, where Trotun now lived. Gesar dismounted and strewed incense upon the ground. Suddenly the plains were crowded with cattle, and bearded goats leaped on the mountainside. Here and

there white yurts blossomed until forty gleamed in the sun, and in their midst, supported on golden arrows, rose the yurt of a prince.

Gazing from afar, Trotun saw the fair encampment, and he summoned Sanglun, whom he had made his vassal to tend his herds. "Go to the strange tribe who have pitched their tents on our land," Trotun said, "and say to them that for each day's stay in the realm of King Trotun, they shall yield him tribute of a herd of cattle. If they will not, he will scatter them like snowflakes on the icy blast. And the first herd shall be yielded up tomorrow!"

Sanglun mounted his old horse, which could scarcely support his master's weight. The old horse had worked too long, and now he yearned for the ease and comfort of green pastures, where he might muse on his exploits, singing their glory to his children's children. But Trotun had commanded that he serve Sanglun, saying, "You are well matched, an ancient beggar and his ancient steed!"

Now as they made their way to the camp of the strange tribe, the horse broke into speech. "How my toil-worn bones cry out beneath you, beloved master! If I had not been born with a hero's heart, I would fold up my legs, one upon the other, and not move again from this place."

"Take heart, my friend," answered Sanglun, "and I will beg fodder from these strangers to comfort you.

If their bounty matches their wealth, they will not deny me, for never since Gesar left us desolate have I seen so fair a camp."

From far off Gesar saw the old man on his horse and knew he was Sanglun. He said to Brugmo, "Old Sanglun draws near to parley with us. Welcome him, and bid him eat and drink. Let him be given the hind-quarter of an ox and let tea be offered to him in my bowl of horn. I will listen to what he says from behind the hanging."

Dismounting before the princely yurt, Sanglun called out, "A courier from King Trotun seeks audience here!"

Brugmo came forth and answered, "What king is this and what greeting does he send us?"

"He who is king of Tibet through his evil deeds bids me say to your lord that for each day's sojourn within his borders you shall yield him tribute of a herd of cattle. If you will not, he will scatter you like snowflakes on the icy blast. And the first herd shall be yielded up tomorrow!"

"It is well, Father, and when my lord has returned from the chase, he shall hear the word of your master. But now you are weary, and within the yurt there is meat and drink for your pleasure. Enter and feast!"

"I will gladly enter and feast, kind youth, but first I would beg fodder for my steed, whose hunger is greater than mine!"

"He shall have fodder such as the steeds of heaven graze upon on the cliffs of Sumeru!" Brugmo clapped her hands and suddenly a green meadow appeared before them, where lotus flowers bloomed and golden wheat, and streams flowed in the shadow of wide-spreading trees. Sanglun led his steed to the green meadow and then entered into the yurt.

There on a cloth of felt a feast was laid of the hindquarter of an ox, and savory tea steamed in a bowl of horn. When Sanglun saw the ox he laughed out loud, for since he had served Trotun he had eaten nothing but roots and bitter herbs, and drunk the dregs at the bottom of caldrons.

From behind the hanging Gesar saw how he tore the meat with his hands. Feeling deep sorrow, he flung to Sanglun the crystal-handled blade that hung at his waist. Seeing the blade, Sanglun wept bitterly.

When he had eaten, he lifted the savory tea to his mouth and laughed out loud. But noticing the bowl of horn from which he drank, he wept, his tears flowing into his beard.

"It has been said that laughter should be welcomed, but weeping forsworn," said Brugmo. "Why did you laugh at the sight of the ox meat but weep at the sight of the blade? Why did you laugh at the sight of the savory tea but weep at the sight of the bowl?"

Sanglun answered, "I could not help but laugh at the sight of the meat and the savory tea, for since I have served Trotun, I have eaten nothing but roots and

bitter herbs, and drunk the dregs from filthy caldrons. But when I saw the crystal-handled blade and the bowl of horn, I knew they belonged to Gesar. Then I could not choose but weep, for my heart cried out, 'Your blade and your bowl have returned, my son, but you have perished.'"

Gesar, hearing these words, was filled with compassion, and he came forth from behind the hanging, saying, "Weep no more, for Gesar is not dead, but lives. He will return to avenge your wrongs and the wrongs of his people, and you shall rejoice with the joy of the shining gods. But now ride back to Trotun, and do not say anything about what you have heard. Take this haunch of a sheep to your wife, so that she too may eat."

Brugmo led Sanglun forth from the yurt. The magic field had vanished, but a steed pawed at the earth, his eyes flashing fire and his mane and tail like silken banners in the wind. On his back Sanglun saw the saddle and bridle worn by his ancient steed.

"This is a steed fit for the gods to ride," said Sanglun. "But where is the faithful friend that brought me here?"

The steed answered, "Do you not know me, master? I am the faithful friend that brought you here, but I have eaten fodder such as the steeds of heaven graze upon on the cliffs of Sumeru, and I have grown as fair as they."

When Sanglun had mounted him, he bounded forward, and the old man struck him over the thigh with the sheep's haunch, crying aloud, "Will Gesar indeed return? Or is this a dream that I dreamed as I lay sleeping?"

The horse answered, "This is no dream—for don't you have the sheep's haunch? Until now who has given you so much as a sheep's skin to shelter you from the cold?"

Sanglun's heart was uplifted, and he spurred his horse onward until they came to the place where Trotun sat on Gesar's throne, waiting for Sanglun to return. Forgetting the command that had been given him, Sanglun said, "Beware, son of evil, who has usurped the throne of the mighty one! Gesar's name will blossom like the lotus flower, but the name of Trotun will be like a torch that is extinguished and trampled in the mud!"

"For such brave words you shall have brave blows, my brother!" Trotun answered. He commanded that Sanglun be beaten with sticks of fresh-hewn wood, and having been beaten, he was carried back to his yurt of black felt and flung to the earth.

Amirtasheela wept to see his wounds. "Alas, my husband, your wounds flow red with blood, but where is our son to avenge your wrongs?"

Sanglun answered, "In the tent of the strange tribe I saw the crystal-handled knife that used to hang from Gesar's waist, and the bowl of horn from which he

used to drink. And one said to me, 'Gesar is not dead, but lives. He will return to avenge your wrongs and the wrongs of his people, and you shall rejoice with the joy of the shining gods.' Beneath my robe is the haunch of a sheep that he gave me for you to eat. Therefore be comforted; eat this meat and lie down and sleep." Amirtasheela ate the meat offered her, and laid down and slept.

But the next morning she went to the camp of the strange tribe. From far away Gesar saw her coming but did not know her, because her face was veiled with many veils. He went forth to greet her. "What is it that you wish from us?" he asked.

She answered, "The all-conquering, all-healing Gesar is my well-loved son. The gods gave him the power to transform himself into whatever he wished, but forbade him, whatever shape he took, to disguise the forty-five teeth with which he was born." Amirtasheela took off her veils, saying, "As I am your mother, so are you my son!"

"I would have remained hidden from you, good mother, until I had avenged you," Gesar said. He embraced her three times, and Amirtasheela wept and laughed in turn, not knowing for joy whether she was waking or dreaming.

"Go with Brugmo and climb the hill yonder that overlooks the valley," Gesar counseled her, "and you shall see how Gesar metes out justice to traitors!"

With Brugmo, Amirtasheela scaled the height that overlooked the valley, and saw how Gesar mounted his lowly ass and took his way to Trotun.

Trotun sat enthroned at the entrance of his yurt, awaiting the stranger's coming. Gesar approached, but he drove no herd before him, nor did he dismount to pay homage to Trotun. He gazed at Trotun and said nothing.

"Where is the herd of cattle that I commanded of you?" said Trotun. "And why do you remain seated on your mount, and not bow to me in homage?"

"I bow to the gods, and I heed the commands of the Everlasting Ones, but none besides."

"Who are you, rash fool, that dares to brave the wrath of the glorious Trotun?"

"I am one who has ventured through many lands and encountered many perils, and I have come to mete out justice to the vile Trotun."

Gesar flung off the semblance of a merchant and sat in splendor astride his marvelous brown horse, clad in his armor fashioned of seven jewels that sparkled like the dew at dawn. His helmet, wrought of the woven light of the sun and moon, adorned his noble head. His ebony bow was girded about his shoulders, and thirty silver arrows, notched with turquoise, lay in his quiver. Drawing his lightning-sword three fathoms long from its sheath, he advanced upon Trotun.

But Trotun fled before him into the yurt, and crept into a sack and tied it shut. "Let a white cloud as big as a sheep come from the east!" Gesar said. "Let a black cloud as big as a heifer come from the west!" In the east a white cloud as big as a sheep appeared, and in the west a black cloud as big as a heifer. Each sped swiftly to meet the other; crashing together, they released a whirlwind that descended to the earth and tore the yurt from over Trotun's head, bearing it aloft to the high mountain ridge where Brugmo and Amirtasheela kept watch, and setting it down unharmed beside them.

Gesar dismounted from his horse, and approaching the sack where Trotun lay hidden, said, "This sack is foul with vermin! Let us drive them out!" And he thrust his blade through its side.

The sack trembled, but no sound came from it. Gesar thrust in his blade a second time, more deeply than before, and the sack rolled from side to side but still no sound came forth. He thrust his blade in to the hilt, and a stream of blood gushed out and a voice cried, "There are no vermin here, but your kinsman Trotun, whom you have sorely wounded." And he crept out of the sack.

"Whose kinsman was Shikar when you betrayed him to the three Shiraigol kings?" said Gesar. "Was he not your kinsman? Whose kinsman was Gesar when you delivered his chosen wife up to his enemies? Was

175

he not your kinsman? Woe, woe unto you, Trotun, for my wrath is like a burning fire that leaps to heaven and will not be quenched except by your blood!" Slowly Gesar advanced upon him with a drawn sword.

But before he could strike, Sanglun flung himself down before him. "Dread son of heaven!" he cried. "By his evil deeds this traitor has earned death a hundred times, by sword, by flame, and by the lashing of many scourges. Yet he is my brother and of noble blood and your close kin. I pray you, curb your great wrath and do with him whatever you will, but do not slay him."

Gesar answered, "Because I love you, I will not kill him." Sheathing his sword, he raised Sanglun up and embraced him three times.

He said to his wondrous horse, "Gulp down the traitor Trotun nine times and release him again, so that he is drained of the power whereby he has wreaked evil upon his fellows."

The brown steed did as Gesar bade him. When his task was done, Trotun lay upon the ground and did not get up, for his strength was less than the strength of a hair.

Gesar then said to Sanglun, "Lead me to the battlefield where the thirty heroes perished for my sake."

Sanglun led him to the battlefield strewn with the bones of the thirty heroes. Gesar, seeing the bones, lamented, "Where are you, Nantsong my Falcon, ever eager to rush into the forefront of battle? And you, Shumar, Eagle among warriors, laughing as you hurled back the ranks of the enemy? Where are you, my Tiger-hero and flaming Bodotshi and all my comrades who were like the talons of the lion to me, and as torches that light the darkness? With hearts like boulders you repelled the enemy until you were betrayed and slaughtered, while I, who should have led you into battle, idled in the land of the twelve-headed giant, vanquished by Aralgo's guile!" Gesar could scarcely express his sorrow for weeping, while Sanglun could scarcely hear his words for grief.

But the brown steed chided his master. "You lament, my Gesar, until one who did not know you might say that a woman's soul dwelt in your body and not a valiant hero's. Do not spend your strength in tears, but entreat your sisters on Sumeru to petition Kormuzda for the lives of your heroes."

Gesar scattered incense upon the earth and poured forth a drink-offering. "My glorious sisters," he said, "when I left your abode and the abode of the shining gods by Buddha's will, thirty matchless comrades bore me company. Where are my comrades now?"

The voice of his sisters descended to him from above and answered him. "We will go to our father

Kormuzda, and petition him for the lives of your matchless comrades."

Gesar's three sisters went at once to Kormuzda where he sat enthroned among the thirty-three gods who served him. They bowed nine times, striking their hands together. "Father of the gods and servant of Buddha's will! Our brother has returned from the land of the Shiraigol kings. He now weeps on the battlefield where his thirty heroes lie slain, and will not be comforted."

Kormuzda answered, "If he had not forsaken his heroes to follow Aralgo, he would not now be mourning their death. Yet it is written in the book of destiny that the servants shall mourn their master, not the master his servants. Therefore I will go to Him Who Orders All Things, and learn his will."

Kormuzda went to Him Who Orders All Things, and kneeling before him, spoke. "Jewel in the lotus flower! My son, who by your will descended in mortal guise to rule the earth, has served you well. He has destroyed the seven alwins, slain the Wild Boar of the Wilderness, and put to death the giant with twelve heads together with all his kin. Yet now he weeps on the battlefield where his thirty heroes lie bereft of life at the hand of the Shiraigol kings, and he will not be comforted. Since it has been written in the book of destiny, O holy vessel of truth, that the servants shall mourn their master, not the master his servants, I have come here in all humility to learn your will."

178

He that dispenses justice to gods and men smiled upon Kormuzda and answered, "Because for two hundred years you were forgetful of the command I gave you, therefore your son now weeps over the bones of his lost comrades. Yet I will have compassion upon him, and transform his weeping to laughter and his sorrow to joy through the power of the blessed arshaan."

From an ivory bowl that held the blessed arshaan, Buddha filled a golden chalice, and gave the chalice to Kormuzda. "Let your son sprinkle the bones of his heroes with this holy fluid, and the bones shall be joined together, the sinews shall knit themselves up, and flesh shall cover them once again. Let him sprinkle them a second time, and the breath of life will enter their bodies, making them whole. Let him sprinkle them a third time, and they shall be born anew and rise from the earth."

Kormuzda took the chalice from the Buddha's hand and returned to his dwelling-place where the three glorious sisters awaited him. He gave the golden chalice into their keep, together with the words the Lord Buddha had spoken to him, and they descended to earth.

When they came to the battlefield where Gesar wept over the bones of his heroes, they said, "Because it is written in the book of destiny that the servants shall mourn their master, and not the master their

servants, the Lord Buddha has sent you the blessed arshaan in a golden chalice. Sprinkle the bones of your heroes with this holy fluid, and the bones shall be joined together, the sinews shall knit themselves up, and flesh shall cover them. Sprinkle them a second time, and the breath of life will enter into their bodies, making them whole. Sprinkle them a third time, and they shall be born anew and rise from the earth. This is the word of Buddha to Kormuzda's son!"

Hearing this word, Gesar's soul was flooded with radiance, and he bowed in worship nine times nine times before the All-Compassionate One, and nine times before his father Kormuzda. Taking the blessed arshaan from his sister's hands, he said, "You glorious ones, whose love has followed me as the shadow follows the body, may you be honored above all the dakinis and may your souls be bathed in the sacred blue of the skies!"

He sprinkled the bones of his heroes with the blessed arshaan, and the bones were joined together, the sinews knitted themselves up, and flesh covered them. He sprinkled them a second time, and the breath of life entered into their bodies, making them whole. He sprinkled them a third time, and they were born anew and rose from the earth and bowed in thanksgiving to the gods.

Then they surrounded Gesar and, kneeling before him, kissed the hem of his robe. "Son of heaven,

uprooter of the tenfold evil, lord over all the creatures of the earth, light-spreading Gesar! When the enemy descended upon us, we overthrew him and slew many brave warriors and took captive many herds of horses. For though you were not there to lead us into battle, did not the noble Shikar command us? Yet when at dawn they stole upon us as we slept, our eyes were so heavy with sleep and our limbs with drinking that our strength did not prevail against them and we died on the battlefield. But now the blessed Buddha has restored us. Weep no longer, dear master, but raise us up from the earth and rejoice!"

Gesar raised them up from the earth, embracing each in turn. "My thirty heroes are restored to me in all their strength and beauty. Yet where is he who commanded you? Where is the grey-flecked hawk who came to me in the wilderness, where is Shikar my brother?"

Shikar, with the head of a man and the body and tail of a hawk, flew down from the heavens and lighted on Gesar's hand.

Gesar said, "Shikar, see the blessed arshaan that the Lord Buddha has sent to restore the thirty heroes to life! It will restore you to mortal form as well, if you desire it."

But Shikar answered, "Why should I desire it, Gesar, for my arm is wearied by the blows I dealt at Chatun Stream, and the wound at my throat throbs

181

with a bitter pain, and my heart weeps for the evil deeds of men. Brother, if it please you, I would rather return to the abode of the high gods, and not dwell again on earth."

"Let it be so, Shikar!" Gesar answered. "Return to the abode of the high gods. My sisters will go before you and Kormuzda my father will take you by the hand and give you surcease from pain."

Shikar said farewell to Gesar and the thirty heroes and his father Sanglun, and soared aloft. The three sisters went before him, and when they reached the abode of the high gods, Kormuzda took Shikar by the hand and gave him surcease from pain. His winged charger galloped forth from the heavenly stalls to greet him, and Shikar lived with him henceforth on Sumeru, and did not descend again to earth.

Gesar commanded that a feast be prepared, and invited the thirty heroes and the three hundred chieftains of the tribes, together with all their tribesmen. Brugmo sat at Gesar's right hand, with Sanglun beside her, and Amirtasheela sat at his left hand.

The feast continued a full three months. The sound of their revelry was borne all over the land and even down to the deepest caverns of the sea. Clouds of fragrant incense floated upward in tribute to the gods, and by night the radiant lingho-blossom opened its chalice, lighting the darkness.

When the feasting and merrymaking were done, and the heroes and chieftains had returned to their homes, Gesar ascended his golden throne, bearing the sword of righteousness in one hand and the balm of peace in the other. Having uprooted the tenfold evil and restored gladness to the hearts of men, he lived among them in the wisdom and joy of the gods, ruling over his people as the sun rules in the heavens and as the mountain rules over the valley below.

Thus ends the tale of the hero Gesar.